IMAGES
of America

ALONG MAINE'S APPALACHIAN TRAIL

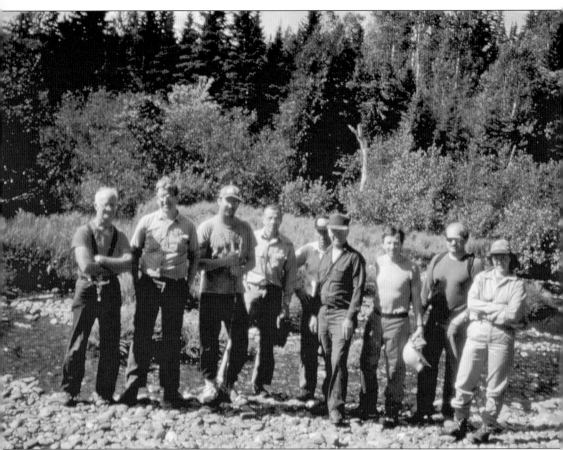

In June 1987, Maine Appalachian Trail Club volunteers, from left to right, Harold Hanson, David Field, Mark Fortin, Frank Trautman, Fernald Curtis, Victor Ardine, Eric Anderson, Mitch Saunders, and Stacy Morin pose at the West Branch of the Piscataquis River during work on the Blanchard Relocation. (Photograph by Charles Gilman.)

ON THE COVER: Myron H. Avery, principal architect of the Appalachian Trail in Maine, called the Bigelow Mountain Range "Maine's Second Mountain." Andrew M. Field looks out over the range from the side of West Peak towards the Horns on July 1, 1975, just one year before the voters of Maine, in a petition-initiated bill, declared that the mountain and its surroundings should be protected from threatened development. (Photograph by author.)

IMAGES
of America

ALONG MAINE'S APPALACHIAN TRAIL

David B. Field

ARCADIA
PUBLISHING

Published by Arcadia Publishing
Charleston, South Carolina

Printed in the United States of America

Library of Congress Control Number: 2010936405

For all general information, please contact Arcadia Publishing:
Telephone 843-853-2070
Fax 843-853-0044
E-mail sales@arcadiapublishing.com
For customer service and orders:
Toll-Free 1-888-313-2665

Visit us on the Internet at www.arcadiapublishing.com

This book is dedicated to the volunteers of the Maine Appalachian Trail Club, without whom the Appalachian Trail would not exist in Maine.

CONTENTS

ACKNOWLEDGMENTS

First and foremost, I wish to acknowledge the influence of my older brother Michael T. Field, who first inspired my interest in the Appalachian Trail more than half a century ago and who contributed a number of the photographs used in this book. Other photographers who provided images are Stephen Clark, Terry Karkos, Lester Kenway, Richard Innes, John Morgan, Tony Barrett, Michelle Curtain, Christine Wolfe, and the author. Other images appear courtesy of the Appalachian Trail Conservancy (ATC, formerly the Appalachian Trail Conference), the Maine State Library (MSL), the Phillips, Maine, Historical Society (PMHS), and Tim Harrison of Harrison's Pierce Pond Camps (PPC). Unless otherwise noted, all images appear courtesy of the Maine Appalachian Trail Club (MATC), from its archives. Special thanks for help and advice are due to MATC historian Ray Ronan, MSL reference librarian Melanie Mohney, Elaine Morgan at the PMHS, Brian King at ATC, Tom Johnson at the Potomac Appalachian Trail Club, and Duluth "Dude" Wing of Eustis, Maine.

In order to really tell the story of the Appalachian Trail in Maine, it was necessary to carry the record from the earliest surveys in the 1920s to the present. Unfortunately, most of the photographs taken during and after the 1950s are colored slides. It is very difficult to scan these small images up to the size required for publication, so only the best could be used. Many scenes that tell the story are not included in the book, and many people who contributed greatly to the creation and perpetuation of the trail in Maine do not appear. The images that are included still tell a wonderful story.

Information about the first 30 years came from the Maine Appalachian Trail Club archives; the remaining 50 years relied on the archives and the author's personal knowledge. The author has scanned nearly 10,000 documents from the archives and continues to extend that record.

INTRODUCTION

The Appalachian National Scenic Trail extends for 281 miles across Maine. Without the tenacity of Lubec, Maine, native Myron Haliburton Avery, the trail might have ended in New Hampshire. Without the support of private landowners, the Maine Forest Service, the Maine Warden Service, the Civilian Conservation Corps, and many volunteers, Avery might have failed. Without the 75-year dedication of the volunteers of the Maine Appalachian Trail Club, Maine's AT would not exist. Without the protection of lands along the trail by the National Park Service and State agencies, the trail experience would be less than it is.

This is the story of the people who created and maintain the Appalachian Trail in Maine, Myron Avery's "Silver Aisle." It tells how the trail route was planned, scouted, blazed, and built, including completion by young men of the Civilian Conservation Corps of the final two miles of the entire Appalachian Trail on August 14, 1937, on the high ridge between Spaulding and Sugarloaf Mountains in western Maine. It tells of the lands, towns, fire towers, logging operations, sporting camps, and railroads that form a rich history through which the trail passes. Finally, it focuses on the volunteer trail builders and managers who have cared for the trail in Maine for 75 years, including the enormous task of relocating 164 miles of the original 262-mile trail during 1970–1990 and the challenges of placing lands along the trail into public ownership following passage of the Federal National Trails System Act in 1968.

Along Maine's Appalachian Trail is a journey through space and time. The physical trail runs from the New Hampshire border in the Mahoosuc Mountains to Baxter Peak on Katahdin. The story of the trail extends from the mid-1920s to today. Today's trail is far different from that which first took shape 80 years ago. As early as 1924, published accounts of plans for the Appalachian Trail (Torrey, 1924) called for it to extend to the summit of Maine's Katahdin. The earliest recorded exploration was by Arthur C. Comey (chairman of the New England Trail Conference) and others from Grafton Notch to the summit of Old Blue Mountain in 1925, only four years after Benton MacKaye's article in the *Journal of the American Institute of Architects* that proposed what became the AT. Around 1926–1927, Maine game wardens cut a trail from Katahdin to Squaw Mountain, following an unrealized idea for a trail that would extend all the way to the White Mountain National Forest. During the first 10 days of August 1929, Comey and G. Arnold Wiley scouted from Old Blue north to Indian Pond on the Kennebec River. Following the 1929 trip, Comey wrote in a letter to Arthur Perkins, "It is my opinion that no lasting progress can be made in Maine except through local Maine action. When they come to believe that a through trail will help them they will open it." Beyond the Appalachian Mountain Club's Mahoosuc Trail System that ended on Old Speck Mountain above Grafton Notch, there were very few existing trails—mostly fire tower access paths and forest telephone lines—that could be incorporated into the route of the AT. Moreover, Maine had no statewide trail building association that might be recruited into the work. The ATC leadership came close to abandoning the Maine section.

By this time, Myron H. Avery had become interested in the trail. A Lubec, Maine, native, Avery was the driving force behind the creation not only of the Appalachian Trail in Maine but also much of the rest of the path. A graduate of Bowdoin College and Harvard Law School, Avery worked as a maritime attorney in Washington, DC. He was the first president of the Potomac Appalachian Trail Club, chair of the board of managers of the Appalachian Trail Conference from 1931 to 1952, and founder of the Maine Appalachian Trail Club in 1935. He served from 1935 as overseer of the trail in Maine, then president of the Maine Appalachian Trail Club until his sudden death in 1952. As Avery tried to convince the leaders of the Appalachian Trail Conference to extend the trail into Maine, he knew that he faced a daunting task. He differed strongly with Comey about procedure, arguing that scouting routes without marking them was not productive and that establishing a trail route was more likely to encourage local organizations in support of those routes than first trying to form the organizations.

Avery had some knowledge of the terrain in western Maine (during 1918 and 1919 he worked for the Maine Forest Service on telephone lines in that area) and had explored the Katahdin region extensively, but he knew less about the areas in between. He found support in a remarkable character, Walter D. Greene, whom he met by chance during exploration in the area north of Katahdin. Greene was a Broadway actor and a registered Maine Guide who made his summer home in Sebec, Maine. His guide work had made him very knowledgeable of the land around and south of Katahdin. During the summer of 1932, he made several trips into the woods between Katahdin and Blanchard to work out a route for the Appalachian Trail and began to scout and blaze the route across the formidable Barren-Chairback Range. Shailer Philbrick (1983) recalled climbing Third Mountain in the range and finding a small spruce tree with a long blaze cut on its south side. Written on it was, "First Blaze on the Appalachian Trail—Walter Greene." Philbrick wrote, "That was the first blaze on the trail between Mount Katahdin and Mount Bigelow." Philbrick camped with Lyman Davis, 1929 graduate of the University of Maine's Forestry program, on Barren Mountain in 1931 while doing fieldwork for his geology PhD dissertation at Johns Hopkins University. In 1932, Philbrick, Davis, and Monson quarryman Elwood Lord marked the route from Slugundy Gorge on Long Pond Stream to the saddle between Barren and Fourth Mountain.

In March 1933, guided by Comey's and Greene's scouting work, and a route from Blanchard to Dead River Village that had been worked out by Maine Forest Service supervisor Robert G. Stubbs, Avery drafted chapter 6 of the New England Trail Conference's *Guide to the Appalachian Trail in New England*. He wrote that the only part of the Appalachian Trail that had actually been cleared in Maine was from the New Hampshire line to Grafton Notch, but that funds had been raised from the Maine Development Commission, the Maine Forestry Department, the Appalachian Trail Conference, the New England Trail Conference, and private sources to work on the 35-mile section from Blanchard to the Hermitage at the West Branch of the Pleasant River.

In the end, the years 1932–1934 saw a memorable effort by a relative few to get the job done. Avery led an expedition in 1933 to mark the route from Katahdin to the West Branch of the Pleasant River. Walter Greene established the path across to Barren Mountain. Avery's group continued over the route previously marked by Philbrick and on to Blanchard. Philbrick completed the 1933 work by leading a crew from Blanchard to Mount Bigelow, and the final trail blazing was completed in 1934. The original route through Maine was 262 miles long via the Dead River Route; 266 miles long via the Arnold Trail Route. (The entire original AT was 2,056 miles long.) But more than half of the original Maine trail was located on roadways. As an example of the shortcuts used to complete the trail layout, the route described by Stubbs was to follow the Forest Service telephone lines and trails from the Bangor & Aroostook Railroad (B&ARR) in Blanchard all the way to Moxie Bald Mountain, down to Joe's Hole on Moxie Pond, up the Somerset Railroad track, along telephone lines over Pleasant Pond Mountain down to Pleasant Pond, and then along the auto road to Caratunk. Shailer Philbrick, referring to his trip from Blanchard west, called Stubbs "the guardian angel of the trail . . . Mr. Stubbs planned the route in detail, supplied the men who accompanied us, made pertinent suggestions and was the god-father of the whole trip. It was his interest and kindness and cooperation which really made it possible for us."

During the initial scouting, blazing, and cutting of the trail, Avery struggled constantly to find money to finance the work for which volunteers were just not available. In September 1933, Philbrick submitted an estimate of $36.50 as the cost for food to support a two-man crew to mark the route from Blanchard to Bigelow. Avery appealed to forest commissioner Neil Violette and eventually received $45 in ATC funds from Raymond Torrey, who urged Avery to work harder "to get money from the AMC, the Maine Publicity Bureau, and the Bangor & Aroostook Railroad."

In 1935, the Civilian Conservation Corps officially adopted the Appalachian Trail project in Maine. In fact, most of the original route in Maine was built by the CCC, who continued to work on the project through 1940. In addition to clearing trail, the CCC crews built 14 Adirondack shelters (lean-tos) between Grafton Notch and the Kennebec River. But the CCC did not do it all. Louis Wessel, proprietor of the Arnold Trail Inn in Stratton, wrote to Avery in 1932 to say that he had cleared a trail from Stratton to Cranberry Peak on the Bigelow Range and planned to build a shelter at Horns Pond. Bennie Boynton of Nahmakanta Lake Camps helped cut the route down the west side of Nahmakanta Lake in 1933. Leon Potter cut six miles of new trail between Mahar Landing and Antlers Camps along the old GNP "Millinocket Road." Walter Greene cleared much of the route from the West Branch of the Pleasant River to Barren Mountain in 1933. Side trails were cut in 1934 to the summit of Joe Mary Mountain and into Gulf Hagas. Walter Greene cut five trails into the Gulf from the Pleasant River Road in July 1934.

Consistent with his sense of procedure, once the trail had been blazed Avery organized the Maine Appalachian Trail Club on June 18, 1935, to assume supervision and maintenance of the Appalachian Trail in Maine north of the Appalachian Mountain Club's Mahoosuc Trail, which today makes up the first 14 miles of the trail in Maine. Trail maintenance suffered from a lack of workers during World War II, but the MATC continued to grow and to improve the route, becoming the major force behind the management of the trail in Maine. The chain of lean-tos begun by the CCC program was completed by the MATC during the late 1950s. Replacement of the earliest shelters began in the 1960s. Today, none of the original CCC shelters remain along the trail.

During development of the Appalachian Trail through Maine, Myron Avery was in constant contact with landowners over whose property the trail would pass. The route was primarily on private land owned by forest products manufacturers and families that had long held the land for timber production. None of the landowners denied Avery permission to locate the trail across their lands, and it is due to this generosity that the trail continued to exist. George T. Carlisle and Paul Attwood of the Bangor forestry/engineering firm Prentiss & Carlisle were especially helpful, providing Avery with advice on routes and with maps being produced by the firm even as the trail route was being scouted. To this day, MATC volunteers benefit greatly from free access over private logging roads, without which trail maintenance would be much more difficult. In a pamphlet entitled "A Message to Those Who Walk in the Woods," Avery wrote, "First and paramount is the attitude of the walker toward the landowner . . . At all times one must remember that there is no inherent right to walk, camp or use privately owned lands . . . There seems to be abroad too often some theory of public right to use, as one pleases, a wooded area. Any such thought is totally erroneous; you have no more right to use this than to appropriate the well-kept lawn of your neighbor."

However, permission to cross lands did not include protection, and Maine Appalachian Trail Club members regularly faced the task of clearing the footpath of logging slash after a timber harvest. The trail was relocated off from the crest of the Barren-Chairback Range during the Seaboard Paper Company's World War II cutting operations and the fifth edition (1953) of the *Guide to the Appalachian Trail in Maine* included a warning about "difficulties which may be experienced in traversing areas where lumber operations are in progress." Following passage of the National Trail Systems Act in 1968, the MATC negotiated with landowners to obtain greater protection. MATC presidents James Faulkner, Samuel Butcher, Steven Clark, and David Field and MATC treasurer Jean Stephenson, supported by Maine Forest commissioner Austin Wilkins, led this phase of the protection effort. Land use zoning of the Unorganized Territory under the Land Use Regulation Commission established a 200-foot "Remote Recreation Protection Zone" for the trail in the early 1970s. But volunteer efforts failed to obtain results satisfactory to the protection goals of the 1968

Act. In 1984, the National Park Service took over the program of securing a protection corridor for the AT in Maine, eventually buying more than 31,000 acres. Appalachian Trail Project Office managers David A. Richie, John Byrne, David Sherman, and Pamela Underhill and NPS Appalachian Trail Land Acquisition Office chiefs Donald T. King and Charles R. Rinaldi (who also served as an Appalachian Trail Project Office manager) led the NPS land acquisition program. The ATC's executive director, David Startzell, relentlessly lobbied Congress for funding to support the program. ATC's New England field representatives Roger Sternberg, Kevin Peterson, and J.T. Horn and the NPS's AT regional coordinator for the North, Steven Golden, played key roles in Maine's corridor design and land acquisition coordination. Herbert Hartman, director of Maine's Bureau of Parks & Recreation, was the highly supportive key player for the state.

Also in 1984, the NPS signed an agreement with the Appalachian Trail Conference that was without precedent in the degree to which a federal agency delegated the authority to manage public land to a private organization. The ATC was formally assigned the authority and responsibility for managing the lands acquired by the NPS for protection of the AT. That authority and responsibility was re-delegated to the Maine Appalachian Trail Club for the trail north of Grafton Notch. Today, the club not only maintains 267 miles of the Appalachian Trail and related campsites in Maine, together with 55 miles of side trails, but is also responsible for inspecting 301 miles of boundary lines (more than Yellowstone National Park) and more than 2,000 survey monuments and watching for encroachments on more than 31,000 acres of public land. With only about 600 members, the club contributes nearly 20,000 hours of volunteer work related to the Appalachian Trail each year.

One

PLANNING AND BLAZING THE TRAIL THROUGH MAINE

Development of the Appalachian Trail through Maine involved three phases: planning and exploration, marking, and clearing. In the summer of 1932, New Yorker George F. Dillman walked/bushwhacked the route proposed by Arthur Comey from Greenville to Grafton Notch and reported conditions that he found. In April 1932, Maine Forest Service supervisor Robert G. Stubbs wrote to Myron Avery to suggest a more southerly route from Mount Bigelow to Boarstone Mountain, a route close to the final path actually chosen. In August 1933, Myron Avery, J. Frank Schairer, Shailer S. Philbrick, and Albert H. Jackman blazed the trail 77 miles from the summit of Katahdin to the West Branch of the Pleasant River. They were joined there by Walter Greene and traveled over the Barren-Chairback Range along the trail very recently completed by Greene and others, then continued on to Blanchard for a total expedition distance of 119 miles. This first 1933 expedition was delayed for several days by the tail end of a hurricane, so they did not make it to the Kennebec River and had to end at Blanchard. In September, Philbrick extended the route, marking 52 miles to Mount Bigelow with the help of Elwood Lord and Maine Forest Service personnel. In his report, Philbrick stated, "The backbone of the Blanchard to Bigelow link is the Maine Forest Service and they hit the ball all the time." From Mount Bigelow to Saddleback Mountain, much of the route was designed during 1933–1934 by game warden Helon N. Taylor, later supervisor of Baxter State Park. Finally, the route from Saddleback to Grafton Notch was surveyed and blazed by the Bates College Outing Club under the leadership of Prof. William H. Sawyer over eight days in 1934, completing the marking of the trail, but much of the route had yet to be cleared. The fire warden's trail from Grafton Notch to Old Speck Mountain was maintained by the Maine Forest Service but blazed by the MATC. The last 11 miles of the AT in Maine used the Appalachian Mountain Club's Mahoosuc Trail, completed in 1926.

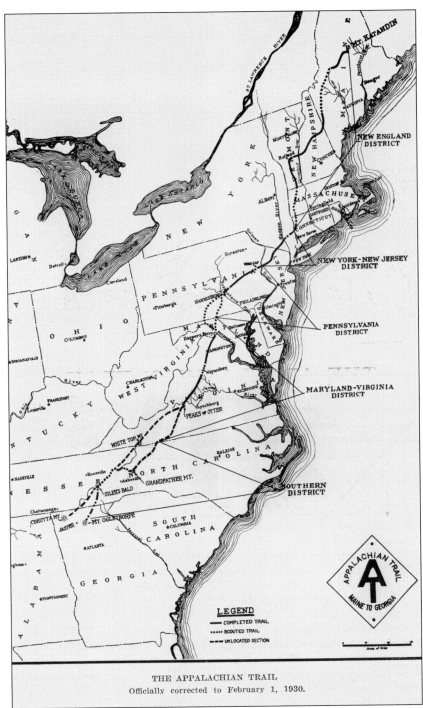

THE APPALACHIAN TRAIL
Officially corrected to February 1, 1930.

In 1930, the planning map for the Appalachian Trail included many dashed lines that represented unlocated routes. This map (on which most of the Maine section appears as a dashed line and the solid line section was later changed) was included in an article by Myron Avery in *Mountain* magazine (Vol. 8, No. 2, February 1930), published by the Associated Outdoor Clubs of America in Pleasantville, New York.

12

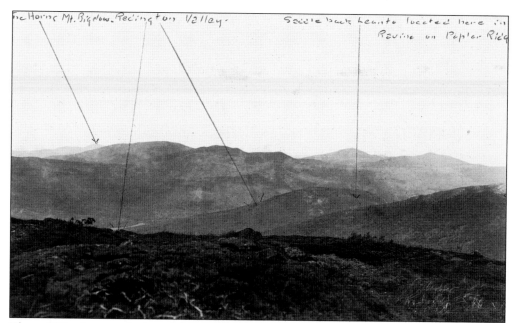

These 1930s photographs from the summit of the Horn (middle peak of the Saddleback Mountain Range) locate mountain peaks and other features along the trail route. The above photograph looks north towards a series of mountain peaks that the AT would eventually cross: Saddleback Jr., Spaulding, Sugarloaf, Crocker (after the trail was relocated off the summit of Sugarloaf in 1974), and the Horns of the Bigelow Range. Identification of the Saddleback Lean-to, built by the CCC in 1937 and later renamed Poplar Ridge Lean-to, is evidence that the photograph was taken after a planned route over Mount Abraham had been abandoned. In the photograph below, the spelling "Abram" for Abraham reflects the name used by locals for that mountain range then and today.

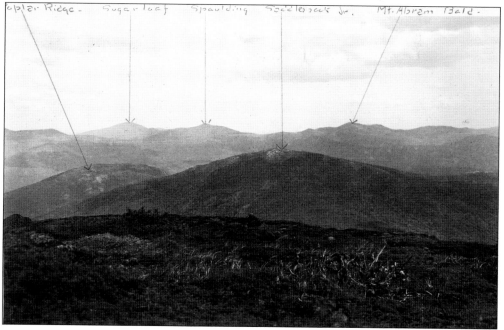

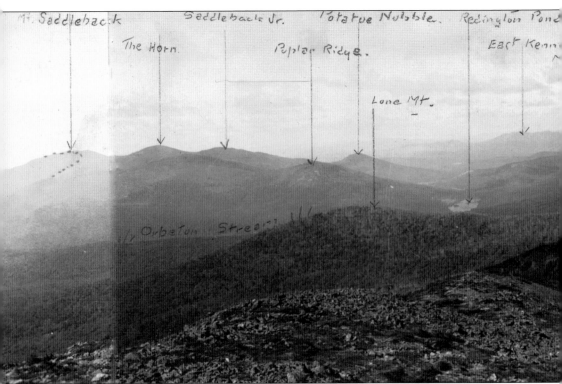

Myron Avery faced the challenge of designing a route for the Appalachian Trail across Maine without good maps of the region, especially maps that showed topography. U.S. Geological Survey topographic maps did not yet exist for most of the route. As an expedient, Avery used photographic panoramas of the landscape prepared by forest supervisor Robert G. Stubbs and Shailer S. Philbrick and plotted prospective routes directly on the photographs. The above photograph shows the

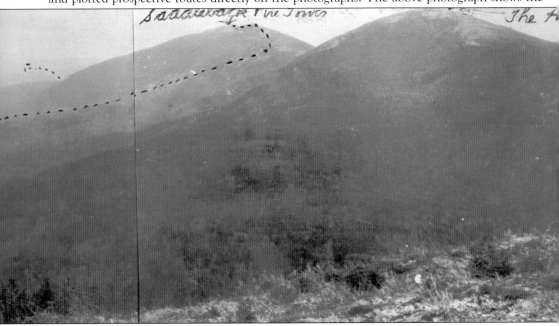

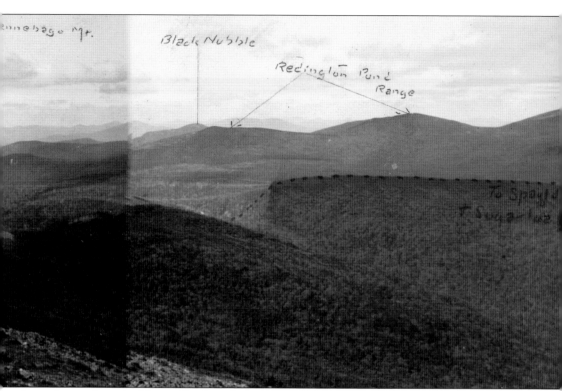

planned route from the Mount Abraham fire tower. In the photograph below, the proposed route seen from Saddleback Jr. shows the trail descending from the summit of Saddleback Mountain into the valley prior to ascending Mount Abraham. In the end, the trail builders cut the path over the length of the Saddleback Range and bypassed Abraham.

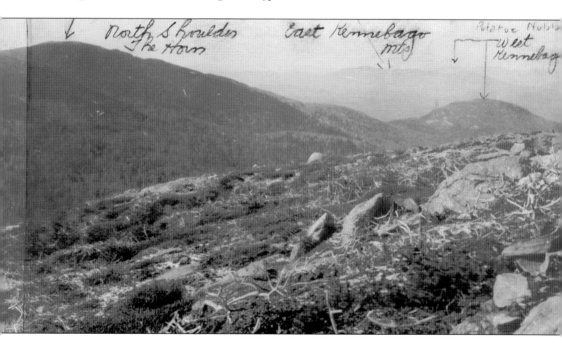

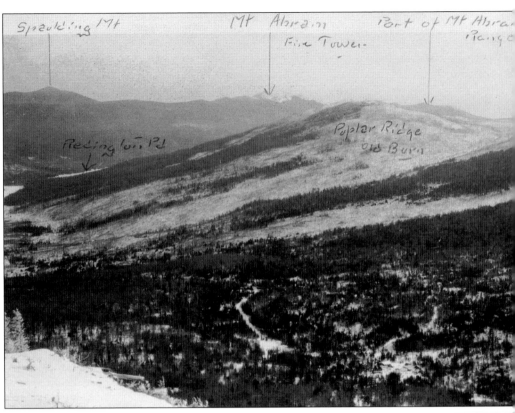

Spaulding Mt

Mt Abram
Fire Tower

Port of Mt Abram
Range

Redington Pt

Poplar Ridge
Old Burn

Pictured here is a 1930s Saddleback planning photograph, taken from Potato Nubble (north of the Horn), that shows not only possible points along the route but also the scar of the early-1900s Poplar Ridge forest fire and an active logging camp along Redington Stream (trail workers scouting for a new campsite in the 1990s found rotting piles of pulpwood in the area).

Trail planners also used panoramas taken from the Mount Bigelow fire tower. This view is looking west towards West Peak (the highest point of the mountain range) and Stratton (photograph below). The tripods, seen to the left of the emergency shelter, supported the telephone line from the watchman's cabin in Bigelow Col to the fire tower. The lower photograph looks east over Little Bigelow.

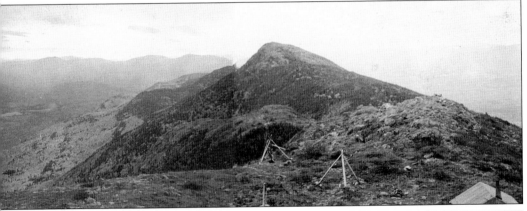

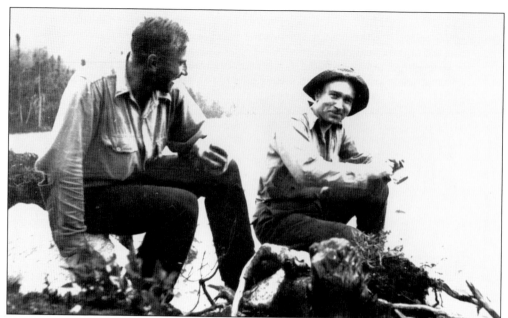

On their way to the summit of Katahdin to begin the 1933 trailblazing expeditions, the crew paused at Basin Ponds. In apparently good spirits at the beginning of the trip, from left to right, J. Frank Schairer and Myron Avery appear to share a joke on August 18, 1933, the day before they placed the first sign on the summit of Katahdin and began the trip south.

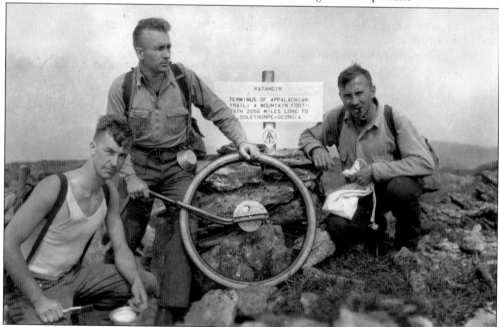

This is the iconic photograph from the 1933 expedition during which 77 miles of the Appalachian Trail were laid out from the summit of Katahdin to the West Branch of the Pleasant River. In front of the original AT summit sign are Albert H. Jackman (with paint bucket), Myron H. Avery (with measuring wheel), and J. Frank Schairer (with ever-present pipe). The date was August 19, 1933. (Photograph by Shailer S. Philbrick.)

J. Frank Schairer paints the first AT blazes at the Gateway, where the Hunt Trail crests its climb up Katahdin and levels off onto the Tableland. According to Myron Avery, this was the first time a Katahdin trail had been marked by paint blazes.

Avery pauses on the Hunt Trail below the Gateway to look over the landscape that the trail will follow to the south. The Hunt Trail was opened around 1890 by Irving Hunt and was chosen by the early explorers as an ideal route for the Appalachian Trail. (Photograph by A.H. Jackman.)

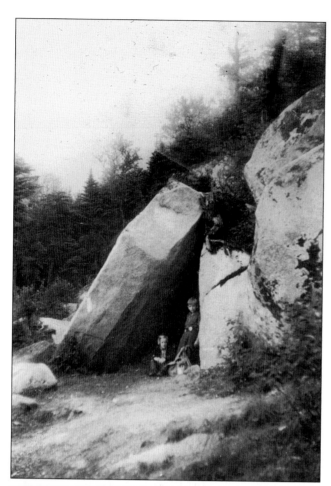

Just below the tree line on the Hunt Trail, this boulder cave beside the footpath is today overgrown by forest. The early trail guides listed this as a shelter, which was true compared to the completely exposed route above the cave, but the Hunt Spur Lean-to, built by the CCC in 1934, was available only half a mile farther down the mountain.

In 1926, retired Connecticut judge Arthur Perkins became interested in the AT project and, in 1928, became acting chairman of the Appalachian Trail Conference. Perkins likely influenced Myron Avery to become involved with the AT. Here, from left to right, Judge Perkins, Ben Flanagan, and Doc Spaulding explore Nesowadnehunk Stream at Little Niagara Falls on August 25, 1925. The AT would later follow the stream into what is now Baxter State Park. (MSL.)

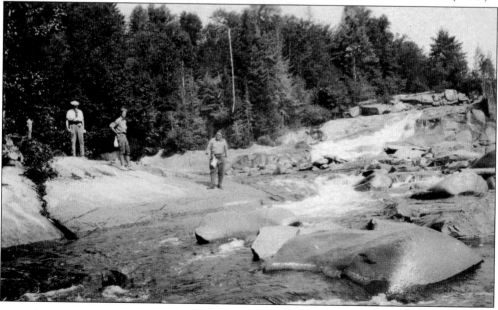

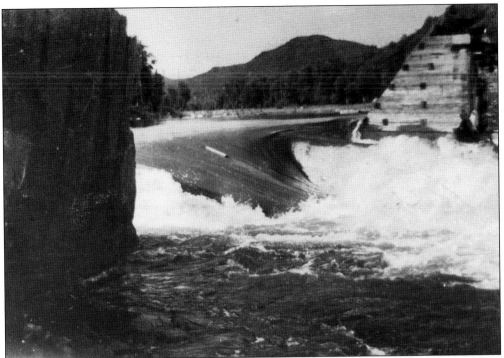

The power of the West Branch of the Penobscot River is clear in this 1930s photograph of Nesowadnehunk (or "Sowadnehunk") Falls. The original plan for the Appalachian Trail was to cross the West Branch over the dam at this site, but it was blown out by floods in 1932.

After the dam was blown, hikers crossed the West Branch by canoe or bateau until the Civilian Conservation Corps built a 207-foot cable bridge at the old dam site in 1935–1936. (Fannie Hardy Eckstorm had suggested that "a birch canoe . . . will give a piquant thrill to your trail which no bridge would bestow.") Here, Avery and his wheel occupy the bow of a canoe crossing at the dead water above the falls.

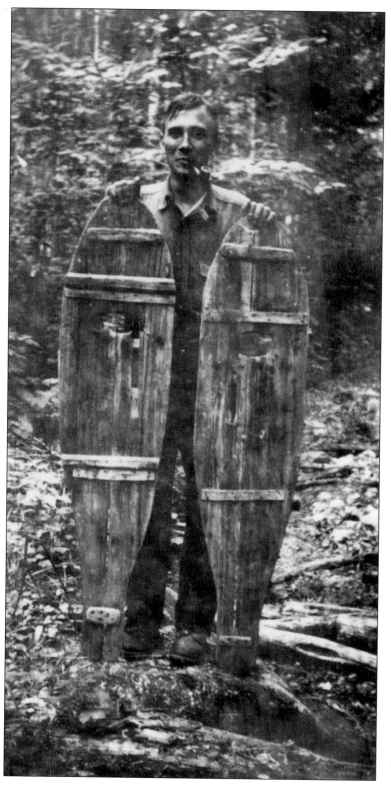

J. Frank Schairer, on the Nahmakanta Tote Road during the 1933 expedition, holds wooden snowshoes reportedly made by a trapper caught in a blizzard. Schairer served as supervisor of trails for the Potomac Appalachian Trail Club, member of the board of managers of the Appalachian Trail Conference, and secretary of the Maine Appalachian Trail Club. (Photograph by A.H. Jackman.)

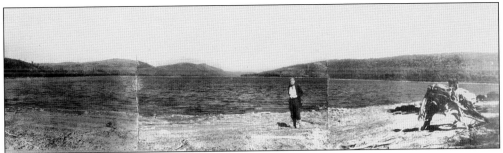

Walter Greene stands on the beach near the outlet of Nahmakanta Lake in August 1933. The original AT was routed past the lake to Wadleigh Pond and back to the north end at the Nahmakanta Lake Camps. The footpath was relocated along the west shore of the lake in 1981, and the entire shoreline is now federal land, administered by the National Park Service.

The route passed along the shoreline of Pemadumcook Lake, where hikers to this day enjoy this dramatic view of Katahdin. Fannie Hardy Eckstorm wrote to Myron Avery in 1932 that Pemadumcook Lake was part of the hunting ground of Penobscot chief Joe Mary in the early 19th century.

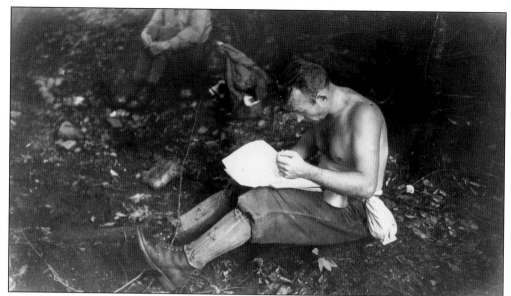

Myron H. Avery studies maps and takes notes during the 1933 expedition. The early trail descriptions prepared by Avery and others were very detailed, as illustrated by this excerpt from the 1942 *Guide*: "At 2.32 m . . . cross brook and turn left on old lumber road . . . at 2.47 m. take right fork . . . cross wide brook at 2.52 m. with small cascade on right."

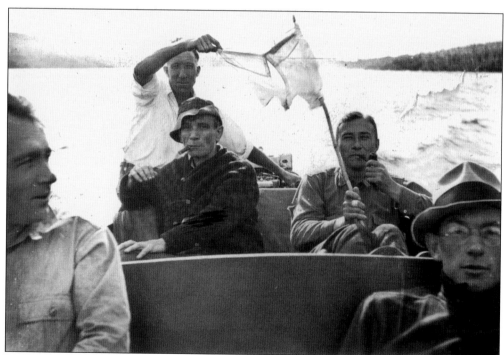

During the great 1933 expedition to lay out the AT from Katahdin to Blanchard, Albert H. Jackman caught this photograph of, from left to right, Myron Avery, Walter Greene, J. Frank Schairer, and Shailer Philbrick being ferried across Rainbow Lake by ? Dyer. No one recorded the significance of the flag. (Photograph by A.H. Jackman.)

During several early-1930s expeditions to seek out the best route, the explorers stayed at Jasper Haynes's Buckhorn Camps on Middle Joe Mary Lake, established in 1897. Although the final route passed further west, participants enjoyed sights such as Balanced Rock, viewed by Buckhorn customers to this day.

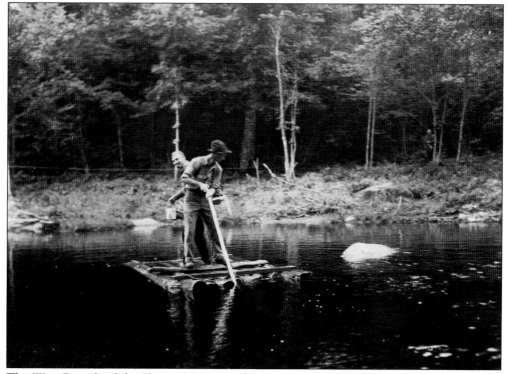

The West Branch of the Pleasant River, at the Hermitage, is usually a wide, shallow ford for Appalachian Trail hikers. But it can be a formidable crossing during high water. In this photograph from the 1933 expedition, Jackman poles a raft across while Schairer maintains a firm grip on the paint bucket.

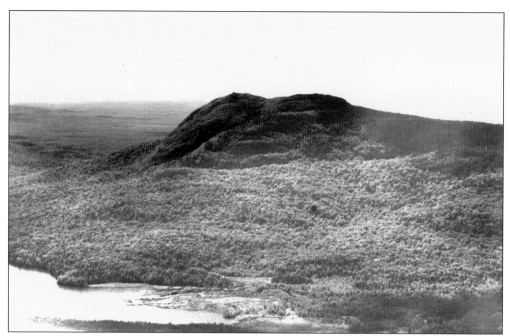

The explorers considered routing the trail over Boarstone Mountain in Elliotsville, seen here over Lake Onawa from Barren Ledges, but decided to keep the path on the Elliotsville Road and to access Boarstone via a side trail. Shailer Philbrick and Walter Greene blazed that trail in September 1933.

Drew's farm in remote Bodfish Intervale, once home to 23 families, provided a rare open vista along the original route. In this 1930s photograph, the ledged face of Barren Mountain looms over Long Pond Stream and the farm's elms and meadows, today largely overgrown. Barren is today heavily wooded but was apparently named after a forest fire denuded the summit.

During exploration for location of the AT east of the Kennebec River in the early 1930s, from left to right, Walter Greene and Myron Avery share a ride in the back of a truck from Blanchard to Bodfish Farm. Nearly seven miles of the trail between Bodfish Farm and Monson were on auto roads until the Elliotsville Relocation was opened in 1987.

Shailer Philbrick worked with Monson quarryman Elwood Lord and Maine Forest Service personnel to blaze the trail 52 miles from Blanchard to Mount Bigelow in September 1933. Here, from left to right, Lord, patrolman George Martin, Bigelow watchman Herbert Blackwell, and patrolman J. Viles Wing pose with their tools—axes, paint bucket, and a hammer for nailing up trail markers. (Photograph by Shailer Philbrick; ATC.)

The route from the south base of Sugarloaf to Orbeton Stream was located and rough cut from 1933 to 1935 by Helon Taylor, with the help of game wardens Roy A. Gray, Phillips, and Smart, as well as Fred Hutchins and Gordon Hunt. Here, wardens Erland Winter (left) and Gray pose at a trail sign beside Route 16. (MSL.)

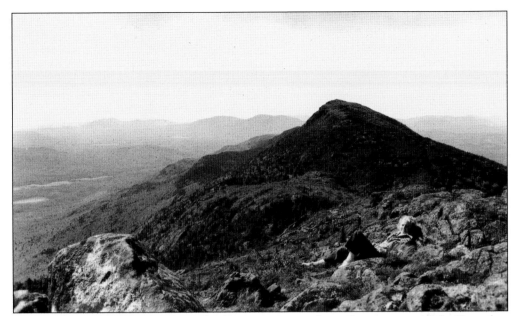

The Bigelow Mountain Range was the first major target for trail scouts west of the Kennebec River. This view from the side of East Peak, over Bigelow Col to West Peak, illustrates the challenge and beauty of the terrain. Watchman Herbert Blackwell built the trail from Bigelow Col to West Peak. Game warden Helon Taylor built the route west of West Peak, as well as part of the seven-mile Bigelow Range Trail.

On September 17, 1933, Helon Taylor wrote, "I have put in two days on a trail to Sugarloaf Mountain and have a trail that is passable to within a mile or so of the top . . . I have a very easy grade and I think you will agree with me that it is the best way to climb Sugarloaf." An easy grade to the powerful Taylor was not so easy for the average hiker.

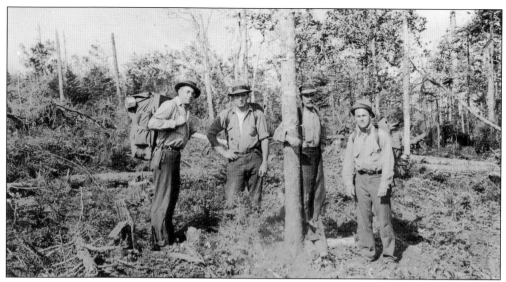

Exploring a route for the Appalachian Trail between Saddleback Mountain and Grafton Notch in 1934, from left to right, Bates College professor William H. Sawyer poses with Samuel T. Fuller (Bates, 1935), lumberman ? McQuilland, and Edward Aldrich (Bates, 1935). (Alicia MacLeay, author of "Blazing a Good Trail"—an online account of this expedition—believes that the photographer was likely Ace Bailey (Bates, 1936).

The 1934 trailblazing Bates crew William H. Sawyer (left), Samuel T. Fuller, warden ? Conant, and Edward Aldrich pause for a photograph at Surplus Pond. The trail still passes the pond at this location.

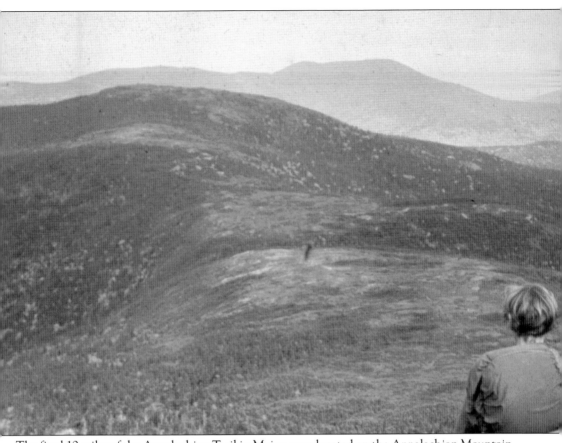

The final 10 miles of the Appalachian Trail in Maine were located on the Appalachian Mountain Club's recently completed (1926) Mahoosuc Trail, seen in this 1962 photograph looking across Mahoosuc Arm towards Old Speck Mountain. Following the Great New England Hurricane of 1938, CCC crews cleared the trail to the Maine/New Hampshire boundary. The lands crossed by the AT came into state ownership in 1977.

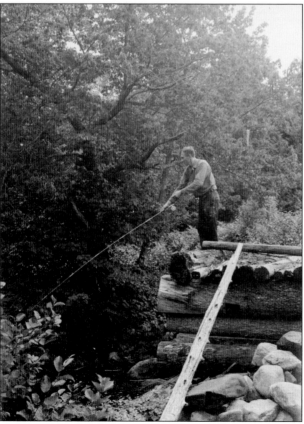

Exploring was all well and good, but the trailblazers needed some time out. A somewhat puzzling photograph finds J. Frank Schairer, an avid fisherman, and A.H. Jackman on the Katahdin Tableland, far from any water body, carrying what look suspiciously like fly rods. There is no doubt what Schairer is doing on top of the old dam over the old East Branch of the Pleasant River (at left). Albert H. Jackman, described by Myron Avery as "a Potomac Appalachian Trail Club mountaineer from the plains of Kansas," earned his PhD in geology and became a professor at Western Michigan University. He was an original director of the Maine Appalachian Trail Club. (Above, MATC; left, MSL.)

Two

BUILDING THE TRAIL THROUGH MAINE

By the end of 1934, the Appalachian Trail had been located and blazed through Maine, but by no means had it been cleared to a usable standard. In 1935, at the suggestion of CCC forester James W. Sewall, the Civilian Conservation Corps officially adopted the Appalachian Trail project in Maine. Avery recorded that crews were sent out from the CCC camps at Millinocket, Greenville, Flagstaff, and Rangeley to work on the existing trail, except between the Kennebec River and Blanchard and from the Pleasant River East Branch to Nahmakanta Lake. The crews improved the clearing, repainted blazes, and cut new trail on sections that had only been blazed. "In addition, a very exact location of the trail route, between Maine Highway 4 and Grafton Notch, was made by C. Granville Reed, under forester Sewall's direction." The Flagstaff CCC Camp partly completed the new "Arnold Trail" route from Pierce Pond to Mount Bigelow via the Carry Ponds. Two crews from the Rangeley CCC Camp completed the route over the Bigelow Mountain range, worked between Sugarloaf and Saddleback Mountain, built 27 miles of new trail from Saddleback to the Andover-South Arm Road, and continued to finish the path over Baldpate Mountain to Grafton Notch. In 1936, the Greenville Camp standardized the trail between Nahmakanta Stream and the East Branch of the Pleasant River and between the Kennebec River and Blanchard. The entire route was re-cleared in 1937 and on August 14, 1937, a CCC crew completed clearing the final two miles of the entire Appalachian Trail, on the high ridge between Spaulding and Sugarloaf Mountains. CCC crews worked from Route 16 to the Maine/New Hampshire border in 1939 to clear the trail of damage caused by the Great New England Hurricane of 1938. A small crew from the Bridgton Camp cleared hurricane damage from Mount Bigelow to the Kennebec River in 1940. The Civilian Conservation Corps also built a chain of campsites with lean-tos from Grafton Notch to the Kennebec River. East of the river, commercial sporting camps provided meals and lodging for AT hikers.

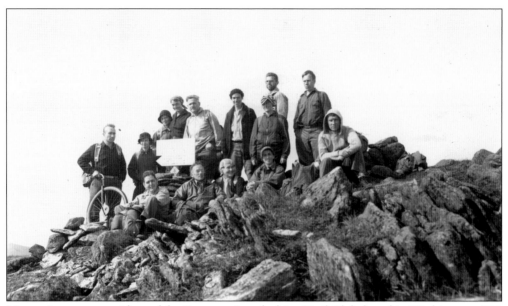

Myron Avery was president of the Potomac Appalachian Trail Club, based in Washington, DC. Anxious for publicity to support the trail project and seeking volunteers to continue clearing the trail, Avery organized three expeditions to Maine for the PATC, in 1935, 1939, and 1941. Here, the group poses on Katahdin's summit at the beginning of the 1935 trip. (Photograph by Mark Taylor.)

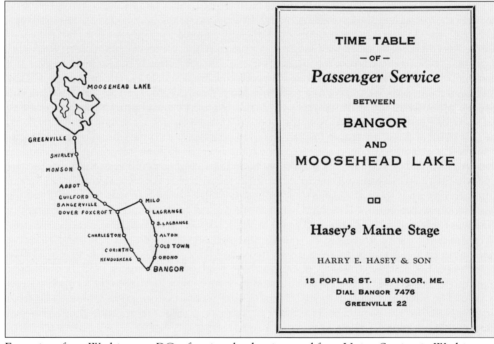

Excursions from Washington, DC, often involved train travel from Union Station in Washington, via the Pennsylvania Railroad's East Wind, to Union Station in Bangor, Maine, from which Hasey's Maine Stage provided the link to the trail in Monson. Train travel was also readily available to other points along or near the trail.

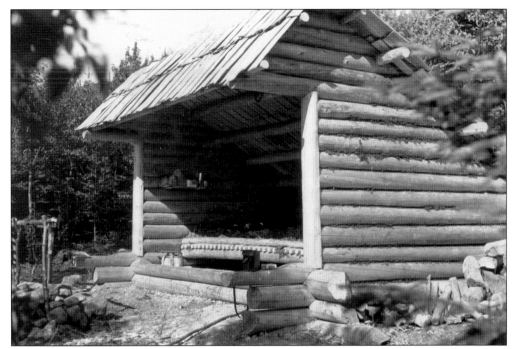

The Civilian Conservation Corps built most of its AT lean-tos west of the Kennebec River, but the Greenville Camp also constructed a number along the Hunt Trail up Katahdin. This brand-new (1934) shelter shows the hand-hewn shake roof and "baseball-bat" bunk poles that characterized the CCC design. A serious flaw found in all of the CCC lean-tos was the failure to prop the base logs up on stones to avoid rot.

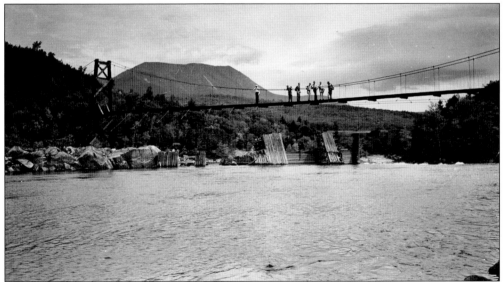

The original Appalachian Trail crossed the West Branch of the Penobscot River at Nesowadnehunk Falls, over a cable suspension bridge built by the Patten Camp of the CCC in 1935–1936. The bridge failed during the winter of 1948–1949 and was rebuilt by the Maine DOT, with help from Great Northern Paper Company (GNP), but ice and storm damage destroyed it again in 1955. Helon Taylor relocated the trail downstream to cross GNP's new Abol Bridge.

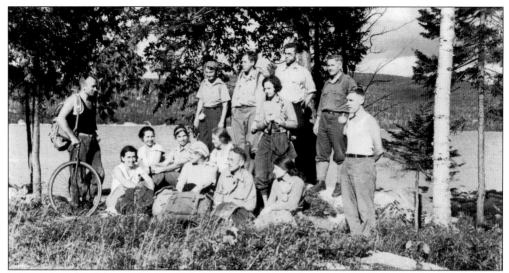

Here, Avery (with his measuring wheel) poses with the members of the 1935 group at Rainbow Lake Camps. Regarding the ferry crossing, Avery wrote "One can telephone Clifford's Camps from Camps above or below on the route and, as the trail data emphasizes this, only a person who takes chances or ignores instructions, can experience any difficulty. As to such a party we need waste no sympathy." (Photograph by Mark Taylor.)

During one of the PATC expeditions, Myron Avery receives plenty of advice as he washes clothes in front of one of the sporting camps. The importance of the camps was emphasized in suggestions for the 1939 expedition: "A most painstaking effort must be made to keep your pack as light as possible. Under no circumstances should your pack exceed 12 pounds." (Photograph by Mark Taylor; MSL and ATC.)

As trail sections were completed, Myron Avery used a homemade bicycle wheel measuring device (he borrowed his first from Judge Perkins) to prepare a detailed description (to the nearest 1/100th of a mile) of features along the route. Here, he measures the trail along the old Rainbow Tote Road in 1935. The original Appalachian Trail design through Maine located 142 of the 262 miles (54 percent) on roads—primarily old logging roads.

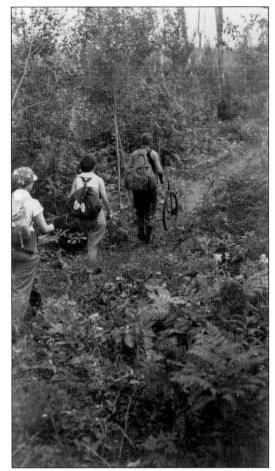

The original AT in Maine included numerous side trails, such as one up Joe Mary Mountain and this one-mile route up Potaywadjo Ridge, from which hikers to this day look out over Lower Joe Mary Lake and the prominent point at the site of the old Antlers Camps. Walter D. Greene and Leon Potter, proprietor of Antlers Camps, cut the side trail in 1934.

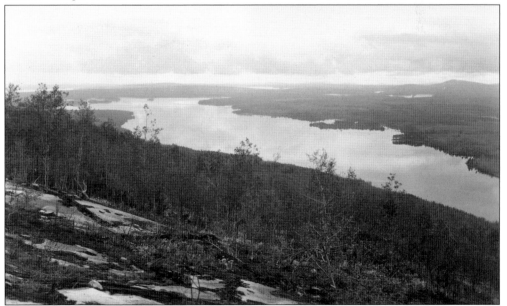

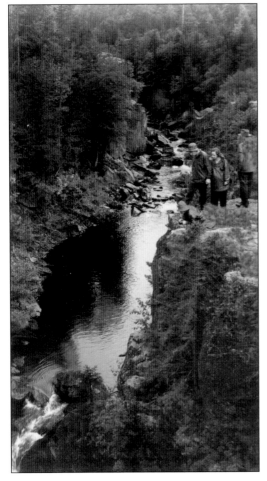

The original trail included north-south mile markers for each of the sections. Self-acknowledged as "a particular hobby" of ATC chair Myron Avery, the markers were regularly renewed until the 1970–1990 relocation era so changed the trail that the MATC decided to abandon them. Many can still be seen along the path. Here, PATC member Egbert Walker paints a marker during the 1935 expedition.

In this photograph, members of the 1935 Potomac Appalachian Trail Club expedition enjoy a view into Gulf Hagas, "Maine's Grand Canyon," from a trail cut by Walter Greene in 1934. The Gulf is now a US National Natural Landmark. (Photograph by Mark Taylor.)

By 1935, the crossing of the West Branch of the Pleasant River was served by a watercraft a little better than the raft used during the 1933 expedition. Here, Avery poles a group of PATC passengers across to the west bank. Today, there is no boat, and hikers must ford the stream, but it is seldom more than knee-deep.

Deputy fire warden Harry Davis, co-owner of Monson's Eastern Spruce Gum Company, offered to take charge of clearing and painting the trail from Bald Mountain to York's Camps on Long Pond. In a February 1933 letter to Myron Avery, Davis said that wages were then $2.50 per day on roadwork and $2 per day on "many common jobs" and estimated that he could clear the route for $85, but that plan was never carried out.

In his classic scrawl, this is the first page of Walter Greene's 16-page letter of July 30, 1933, to Myron Avery in which Greene announces that he has completed the AT across the Barren-Chairback Range, ending at the Hermitage. "Well it's finished. So am I almost, but there's a few kicks left yet if I can whip this poor old tired body along a little further."

On a side trip to the Boarstone Mountain fire tower in Elliotsville during the Potomac Appalachian Trail Club's 1935 hike, PATC president Myron Avery points over Lake Onawa towards the Barren-Chairback Range. The route over Barren, Fourth, Third, and Columbus Mountains was one of the most formidable obstacles to completion of the original AT in Maine.

September 27, 1935.

To Myron Avery:

The undersigned, all members of the P.A.T.C. hiking party in Maine, August 23 - September 6, 1935, desire, by our signatures below, thus permanently to record the sincere appreciation which we feel for the splendid trip which your excellent planning and leadership made possible. In all respects that expedition was, both in conception and execution, an admirable performance. We realize that fact more and more clearly each time we indulge in the happy memories of those delightful two weeks.

We had hoped this evening to present a more tangible token of our appreciation. Unfortunately, however, that token - the identity of which we are not now revealing - is not yet available for presentation. In due season it will arrive at 1850 Park Road.

In the meantime, as written evidence of our grateful appreciation, we subscribe ourselves below.

Harriet L. Caspari *Harold D McCoy*
Orville Crowder *Anna M. Michener*
Katherine Dean *Marion Park*
W. Clark Dean *Jean Stephenson*
Mary Dorsey *Alice Stuart*
Amy Loebel *Mark Taylor*
Ruth E. Lenderking *Egbert H. Walker*

After boarding the train at the end of their journey and returning to Washington, DC, PATC participants in the 1935 expedition sent a letter of thanks to Myron Avery for their "splendid trip." The archives do not record what the "more tangible token of our appreciation" turned out to be.

This brief letter from CCC foreman Leon Brooks to Myron Avery documents the clearing of the last two miles of the entire Appalachian Trail, August 14, 1937, on the high ridge between Spalding and Sugarloaf Mountains. Avery (1938) acknowledged that much remained to be done to truly complete the AT but noted this date as "particularly significant in the annals of trail making."

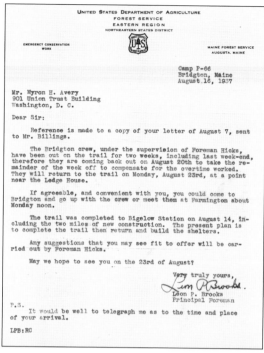

UNITED STATES DEPARTMENT OF AGRICULTURE
FOREST SERVICE
EASTERN REGION
NORTHEASTERN STATES DISTRICT

EMERGENCY CONSERVATION
WORK

MAINE FOREST SERVICE
AUGUSTA, MAINE

Camp P-66
Bridgton, Maine
August.16, 1937

Mr. Myron H. Avery
901 Union Trust Building
Washington, D. C.

Dear Sir:

Reference is made to a copy of your letter of August 7, sent to Mr. Billings.

The Bridgton crew, under the supervision of Foreman Hicks, have been out on the trail for two weeks, including last week-end, therefore they are coming back out on August 20th to take the remainder of the week off to compensate for the overtime worked. They will return to the trail on Monday, August 23rd, at a point near the Ledge House.

If agreeable, and convenient with you, you could come to Bridgton and go up with the crew or meet them at Farmington about Monday noon.

The trail was completed to Bigelow Station on August 14, including the two miles of new construction. The present plan is to complete the trail then return and build the shelters.

Any suggestions that you may see fit to offer will be carried out by Foreman Hicks.

May we hope to see you on the 23rd of August?

Very truly yours,

Leon P. Brooks
Principal Foreman

P.S.
It would be well to telegraph me as to the time and place of your arrival.

LPB:RC

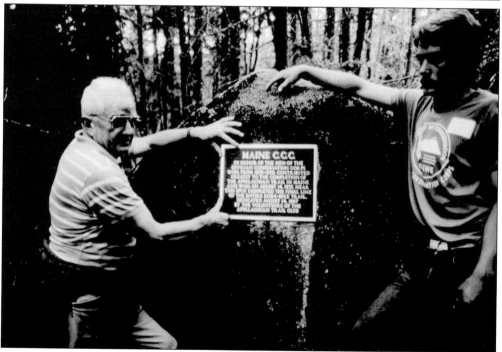

On August 14, 1987, the MATC, the ATC, the NPS, state agencies, and CCC alumni celebrated the 50th anniversary of the completion of the Appalachian Trail. After a ride up the Sugarloaf Ski Area gondola, a group hiked to the middle of the last section cleared. A young man from the Maine Conservation Corps (right) joined Miles Fenton, the only surviving member of the 1937 CCC crew, to dedicate a memorial plaque. (Photograph by author.)

A

MESSAGE

TO

THOSE

WHO WALK

IN

THE WOODS

From the beginning, the trail builders understood the importance of retaining good relations with the owners of the private lands over which most of the Maine AT passed. Written by Myron Avery and published by the Appalachian Trail Conference and trail clubs from Maine to Virginia, this pamphlet sought to foster a trail etiquette that demanded respect for the land and waterways and especially the hazard of wildfires.

By 1942, the planning was done and the trail had been completed, at least for the time being. Avery's "Silver Aisle" was a reality. "This route across Maine is marked by white paint blazes leading through, for the most part, a spruce and fir forest with a cathedral-like stillness; hence this appellation *The Silver Aisle*."

Three

A TRAIL THROUGH HISTORY

Maine's Appalachian Trail passes through a rich historical landscape of aboriginal place names, logging, early settlements, traditional hunting/fishing "sporting" camps, pioneer railroads, forest fire watchtowers, and even slate quarries. Hikers marvel at the "Mahoosuc" mountains; "Mooselookmeguntic," "Pemadumcook," and "Nahmakanta" lakes; "Potaywadjo" ridge and spring. (Somewhat ambiguous translations of these names reflect the often-illiterate European settlers' understanding of what the long-established First Nation folks were saying.) Myron Avery carried on an extensive correspondence with Maine author and historian Fannie Hardy Eckstorm about Maine place names. In a 1932 letter, Eckstorm explained how Moosehead region tourism promoters changed the name of Ship Pond in Elliotsville to Onawa, hoping that the romantic name and legend would appeal to readers of Longfellow's *The Song of Hiawatha*. Very little of the route passed through uncut forest. Waterways along the trail were the primary routes for log and pulpwood drives from the 19th century to 1974, when the Maine Legislature banned further river driving. Hikers pass still-visible remnants of 19th and 20th century timber harvesting operations, including abandoned railroad grades that once served both logging and tourism enterprises. Traveling north, the AT in Maine first crossed the roadbed of the Rumford Falls & Rangeley Lakes Railroad (later the Portland and Rumford Falls Railroad), a standard-gauge line that was abandoned in November 1936. Next came the recently abandoned path of the two-foot-gauge Phillips & Rangeley Railroad (then part of the Sandy River & Rangeley Lakes Railroad) in Redington Valley, encountering another abandoned SR&RL branch (Franklin & Megantic Railroad) in Bigelow Village. After crossing the standard-gauge Somerset Railway branch of the Maine Central at Moxie Pond and the Greenville Branch of the Bangor & Aroostook Railroad in Blanchard, both abandoned, in Elliotsville the trail crossed the Canadian Pacific tracks. Now owned by the Montreal, Maine & Atlantic Railway, this is the only railroad still active that is crossed by the AT in Maine. The original route also passed directly by some of the famous slate quarries in Monson.

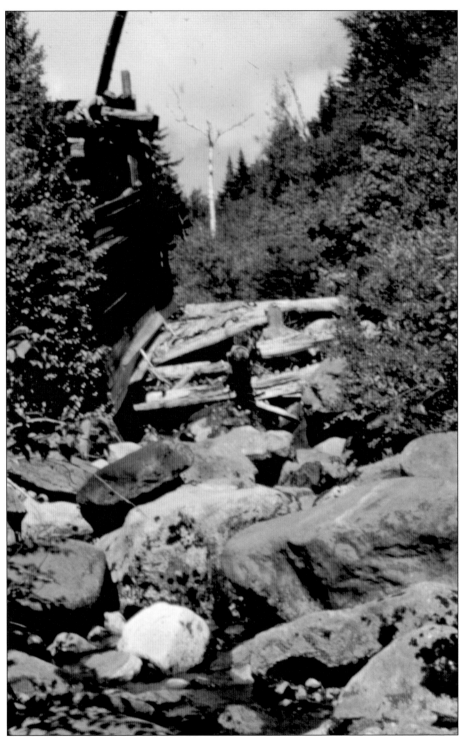

This "splash dam" on Clearwater Brook in Township C was used to impound water on the small brook that could then be used to "flush" logs downstream when the dam was opened. The author is seen inspecting the remains of the dam in 1956. (Courtesy of photographer Michael T. Field.)

Long after this dam was built to enlarge Redington Pond, the new Appalachian Trail crossed Orbeton Stream just downstream from the dam. The dam was expanded and used long after the Redington mill and village were gone, providing an outstanding trout fishing pond until the dam was destroyed in a 1960s flood. (PMHS.)

This old dam at the outlet of Crawford Pond once helped support log drives down Cooper Brook, immortalized by "Mike" Gorman's highly descriptive song "The Drive On Cooper Brook." The AT originally crossed Cooper Brook on the dam.

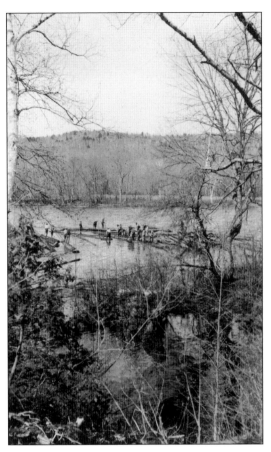

Long logs were still being driven down the Kennebec River past Caratunk in 1933. The AT crossed this major river in Caratunk because of an existing ferry that served clients of Sterling's Pierce Pond Camps. The ferry ceased operation in a few years, and hikers often floated across using sticks of pulpwood. Following a drowning in 1987, the MATC and ATC began a free hiker canoe ferry. (Photograph by Robert G. Stubbs.)

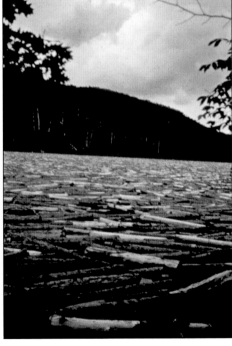

Long after the long-log river drives, Maine rivers conveyed millions of cords of softwood pulpwood until all river driving was banned in 1974. Here, the Kennebec River at the Appalachian Trail crossing in Caratunk is filled bank to bank with four-foot spruce-fir pulpwood. (Photograph by Eliot.)

Great Northern Paper Company's depot on the East Branch of the Pleasant River served an operation in which Lombard log haulers, forerunners of the crawler tractor, traveled over the Cooper Brook Trestle to move wood into the Cooper Brook watershed and on into the West Branch of the Penobscot River.

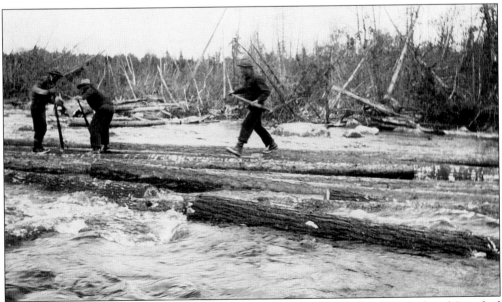

The Appalachian Trail follows Cooper Brook for most of its length, from the outlet of Crawford Pond to Lower Joe Mary Lake. The trail uses a portion of the famous Cooper Brook Tote Road, a Lombard log hauler route, but Cooper Brook was also used for log driving as shown here in the spring of 1932. (Photograph by F.J. Greenhalgh.)

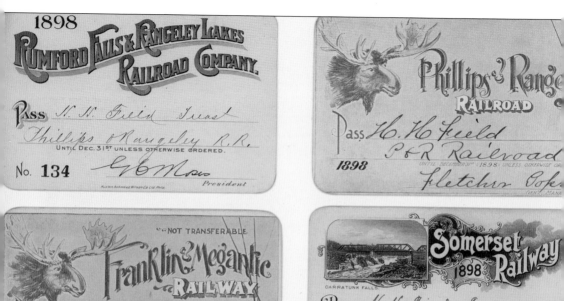

As explorers worked to mark the Appalachian Trail through Maine, the Rumford Falls branch of the Maine Central Railroad, the Phillips & Rangeley and Franklin & Megantic branches of the Sandy River & Rangeley Lakes Railroad, the Somerset Railway, the Bangor & Aroostook Railroad, and the Canadian Pacific Railroad were still operating. When the last link was cut in 1937, all but Canadian Pacific were gone. (Railroad passes courtesy of author.)

The Rangeley branch of the Maine Central Railroad, chartered as the Rumford Falls & Rangeley Lakes Railroad in 1894, was abandoned in 1936 following a devastating flood. Twenty years later, Richard Hoover (left) and David Field (right) pick raspberries beside the Appalachian Trail in the abandoned railroad station village of Summit, marked only by old railroad ties and crumbling buildings. (Courtesy of photographer Michael T. Field.)

The timber township of Redington was opened to transportation by construction of the Phillips & Rangeley narrow-gauge (two-foot) railroad in 1890. This 1915 photograph from a shoulder of Poplar Ridge, later to be crossed by the Appalachian Trail, shows Redington Pond and part of the new village of Redington. (Photograph by Robert G. Stubbs.)

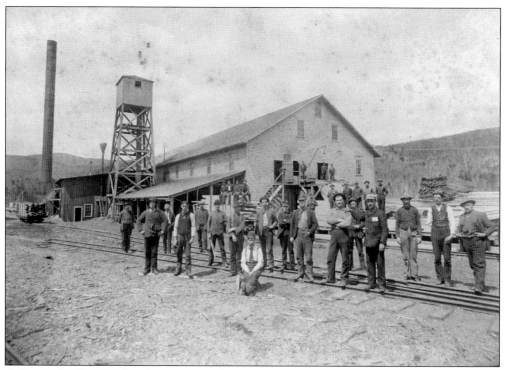

A Boston family owned Redington Township. It had never been harvested for timber before the Phillips & Rangeley Railroad provided access for sending logs and lumber to the outside world. The sawmill was a central part of Redington Village, now only a memory. (PMHS.)

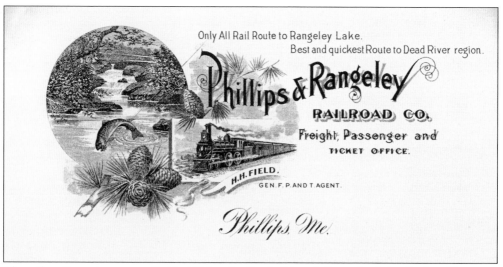

The rails to Rangeley were pulled in 1934 as the Sandy River & Rangeley Lakes Railroad began to shut down. The iron was barely gone when the Appalachian Trail was located down Poplar Ridge, across the abandoned railroad trestle over Orbeton Stream, and along the roadbed for a short distance before heading north towards Spaulding Mountain. (Letterhead courtesy of author.)

This is the Orbeton Trestle of the Phillips & Rangeley branch of the Sandy River & Rangeley Lakes Railroad as it appeared in 1954, no longer usable as a bridge for the trail. The center pier and western abutment were removed in the 1960s to make way for a logging bridge. (Courtesy of photographer Richard Innes.)

Sluice Brook Falls cascades into Orbeton Stream at the high point of a long grade on the Phillips & Rangeley Railroad. Histories tell of an unrealized interest in providing a path down along the falls for the enjoyment of railroad tourists. The 1986 Orbeton Canyon Relocation moved the AT downstream from the old railroad trestle and created the path that had been advocated many years before. (Courtesy of photographer Michael T. Field.)

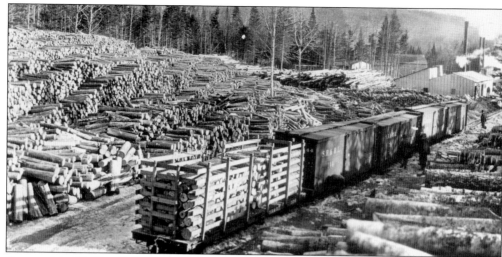

A spur of the Phillips & Rangeley Railroad ran to the village of Barnjum (named for timberland owner George W. Barnjum), created to process timber harvested from the slopes of Mount Abraham. Original plans for the route of the Appalachian Trail in western Maine called for following the abandoned right-of-way of this spur. (PMHS.)

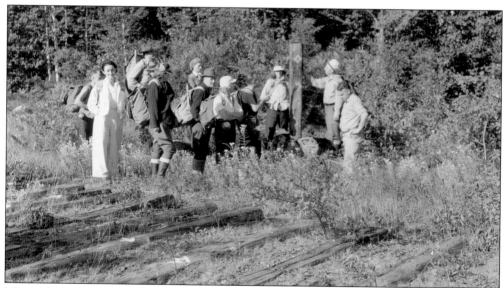

Myron Avery points with his axe handle to a new AT marker at the crossing of the abandoned Somerset Railway bed near Moxie Pond. Started in 1872 and intended to link Wiscasset with Quebec, the railroad carried logs south and passengers north to Moosehead Lake along this section from 1904 to 1928. Tracks were pulled beginning in 1936, five years before this photograph was taken.

Still the Canadian Pacific Railroad when the author took this 1986 photograph, at the AT crossing, of its gleaming welded rails and beautifully maintained roadbed, this is now part of the Montreal, Maine & Atlantic Railway. Hikers camped at the Wilson Valley Lean-to—only half a mile away—have no trouble knowing when a train passes. (Photograph by author.)

Forest fire watchtowers were common along the Appalachian Trail in Maine until they were abandoned in favor of air patrols during the last quarter of the 20th century. This photograph of Katahdin from Rainbow Mountain shows the remains of a forest burned in the Rainbow Fire of 1924. Fred M. Clifford opened the Rainbow Mountain side trail in 1936.

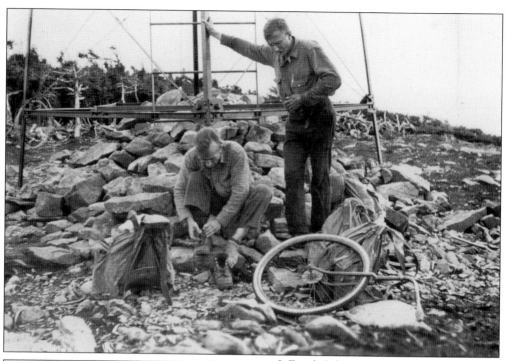

J. Frank Schairer watches Myron Avery retie his boots at the base of the White Cap Mountain fire tower during the 1933 trailblazing expedition. This tower was constructed in 1920 to replace a wooden tower built in 1906. Few photographs in the Maine Appalachian Trail Club archives show Avery without his measuring wheel or Schairer without his pipe.

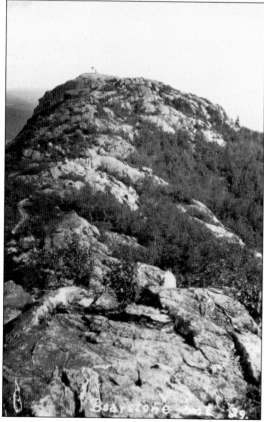

The Appalachian Trail was never routed over Boarstone Mountain in Elliotsville, but the 1913 fire tower atop its rocky summit served as an observation platform for photographs and trail planning across the Barren-Chairback Range. Myron Avery, author and historian Fannie Hardy Eckstorm, and the mountain's owner, Prof. Robert T. Moore, exchanged several letters about the proper spelling—"Boarstone" or "Borestone"—with Moore favoring the latter. The former prevailed.

Moxie Bald Mountain east of Moxie Pond held a fire tower from 1910 to the late 1980s. This photograph was taken from the North Peak in August 1909, looking north towards White Cap Mountain (on right). A side trail from the AT now extends to North Peak, well known to hikers for abundant blueberries. (Photograph by Samuel Merrill.)

The abandoned Moxie Bald Mountain fire tower still stood when this photograph was taken in 1985, but it has since been removed. This steel tower was built in 1919 to replace the original 1910 wooden tower. The location is in the middle of the nine-mile section of the trail that the University of Maine Outing Club has maintained since 1959. (Photograph by author.)

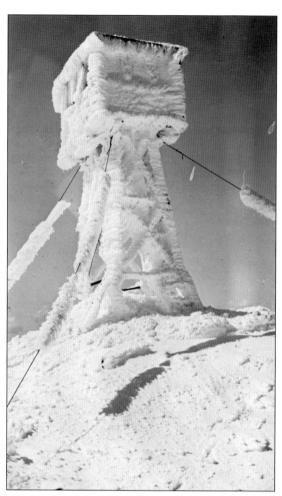

The winter of 1939–1940 was typically harsh on the summit of Mount Bigelow, where the old steel fire tower and the adjacent emergency shelter stood encased in rime ice. In 1953, the Maine Legislature renamed the east peak of Mount Bigelow, where the tower stands, "Myron H. Avery Peak." (Photographs by Fire Warden J. Viles Wing.)

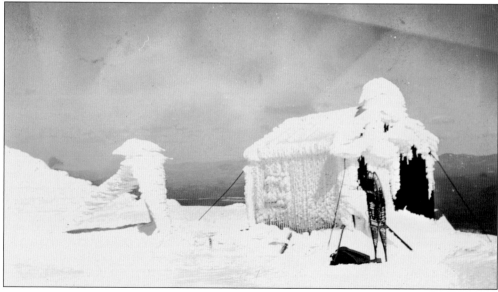

Despite the harsh conditions on the summit, the watchman's cabin in Bigelow Col, boarded up for the winter, remained a snug refuge. The fire tower was abandoned years ago but the cabin remains and is used by MATC volunteers and caretakers. (Photograph by fire warden J. Viles Wing.)

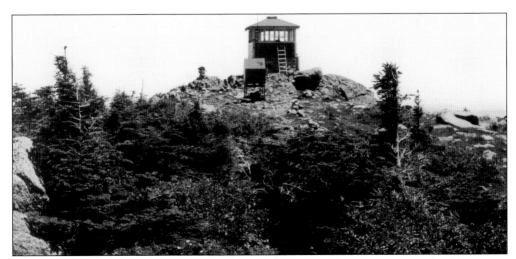

By 1975, the old (1917) steel tower on Bigelow had been replaced by a shorter, more durable version. For years before its abandonment, a Pennsylvania schoolteacher, who enjoyed the solitude of his summer job, staffed the tower. (Photograph by author.)

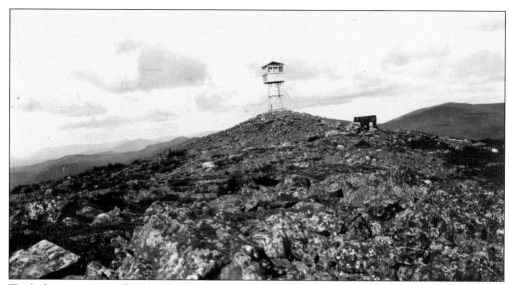

Trail planners originally thought to route the AT over the summit of Mount Abraham, where this 1926 fire tower stood, but the trail was cut over the Saddleback Mountain Range instead. A side trail to the summit of Abraham was cut from the AT in the 1940s but was not maintained. The MATC restored the trail from the relocated AT in 1987.

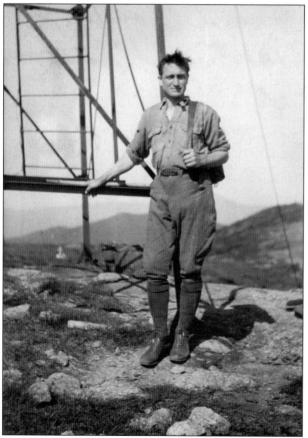

The summit of Saddleback Mountain near Rangeley is one of the most popular destinations for day hikers along the Appalachian National Scenic Trail. Here Frank L. Badger stands at the base of the fire tower a few years after its completion in 1913. Badger worked for a while on the Phillips & Rangeley Railroad then, with his wife, Suselle, founded Badgers Dodge Pond Camps near Rangeley in 1921. (Courtesy of author.)

The cab on the 36-foot steel tower was crushed by ice during the winter of 1937–1938 and replaced. Hurricane Carol in 1954 tore the cab off completely, requiring its replacement again. After brief service as a radio relay facility, the tower was removed. (Photograph by forest supervisor Robert G. Stubbs.)

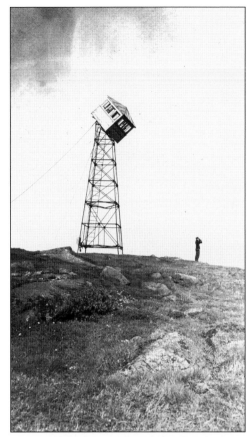

Construction of a cabin near the base of the fire tower on Saddleback in 1951 relieved watchmen from the ¾ mile daily climb up the mountain. An attempt to blast a water catch basin with dynamite (including a detonation shortly after this photograph was taken) failed because the fractured rock would not hold water. (Courtesy of photographer Michael T. Field.)

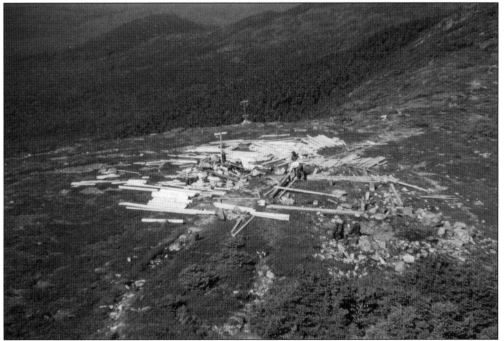

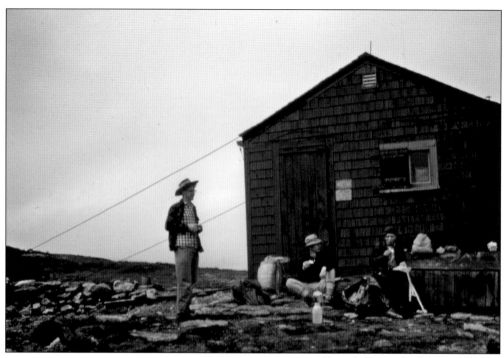

From left to right, Michael Field, Norman Thurlow, and Alan Brackley rest at the Saddleback warden's cabin on a trail-clearing trip in September 1960. The cables were necessary to protect the cabin against strong winds, and the lightning rod directed strikes to ground. Wardens cautioned visitors to the cabin during a lightning storm to not touch anything metal! Even the bed frame was grounded. (Photograph by author.)

Rumors persist that the fall of 1938 Andover North Surplus fire on Moody Mountain was started by woods workers who were unhappy about having to cut pulpwood above the steep cliffs and then push the wood over the cliffs to be picked up in the valley below. When the AT was relocated over Moody Mountain in 1979, trailblazers found remains of pulpwood piles on the edge of the cliffs. (MSL.)

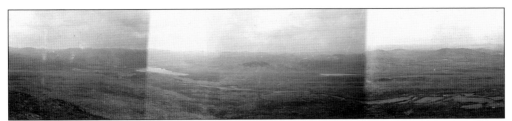

The Appalachian Trail did not pass through the western Maine village of Flagstaff, but hikers have witnessed dramatic changes in the valley north of the Bigelow Mountain Range since this photograph was taken in the 1930s. Flagstaff Village, seen to the left of Flagstaff Pond in the middle center, and the farmlands along Maine Route 16, seen at the right, were buried under the 20,300-acre hydroelectric impoundment Flagstaff Lake in 1950.

The J.P. Morgan Farm in Flagstaff now lies mostly below the waters of Flagstaff Lake, and the land in the foreground of this 1930s photograph of the Bigelow Mountain Range from the farm is also submerged. Duluth Wing, who grew up in Flagstaff village, recalls helping his father guide fishing parties from banker Morgan's camps on Spring Lake, which could house up to 500 vacationing Morgan employees.

The trail passed directly through only three villages—Monson, Blanchard, and Caratunk. The above photograph shows a trail marker at the junction of Maine Route 15 and the Elliotsville Road in Monson. The photograph below shows the trail route along a gravel road heading out of Blanchard Village towards Breakneck Ridge.

The original trail left the Elliotsville Road in Monson and headed north along the "Old Stage Road," passing the Mathews place, built by Capt. Jonathan Mathews in 1824. The author met Jonathan's descendant Robert Mathews at the house in August 1982 and learned that Maine AT pioneer Shailer Philbrick was Robert's cousin. In 1983, Philbrick sent the author a firsthand account of marking the AT with Avery and others in 1932 and 1933.

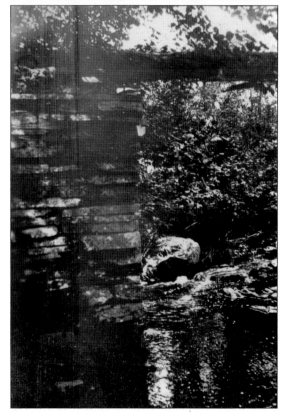

A slate bridge abutment along the "Old Stage Road" (or "Old Savage Road") from Monson to Savage's Mills supports a bridge on the original route of the Appalachian Trail. The settlement began when Nelson Savage cleared land on Little Wilson Stream in 1824 and built a lumber mill, but it had vanished back into forest before 1850.

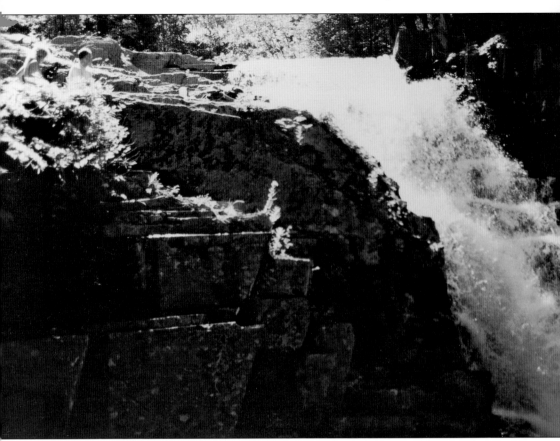

Downstream from Savage's Mills, Little Wilson Stream plummets over a spectacular fall of slate ledges into a long, narrow gorge. David Richie (right), then manager of the National Park Service's Appalachian Trail Project Office, and his daughter Deborah pause here during a 1986 hike from Monson to Katahdin. An attempt to float lumber downstream from the mills to Big Wilson Stream resulted in the destruction of most of the lumber at these falls.

Four

OVERNIGHT ACCOMMODATIONS

Where does one spend the night along the Appalachian Trail in Maine? The original route passed through only three Maine villages. East of the Kennebec River, beyond Sterling's Hotel in Caratunk, hikers were expected to stay in established commercial "sporting camps": Harris' Troutdale Cabins or Folsom's Rainbow Camp on Moxie Pond, lodgings in Monson, Dore's Mountain View Camps or York's Camps on Long Pond, Arnold's Camps on Big Houston Pond, Chadwick's Camps on First West Branch Pond, the Hermitage (after 1941), Berry's Camps on Yoke Ponds, Potter's Antlers Camps on Lower Joe Mary Lake, Myshrall's White House Camps on Pemadumcook Lake, McDougall's Camps on Nahmakanta Lake, Clifford's Rainbow Lake Camps, and York's Twin Pine Camps on Daicey Pond. The Great Depression and the war years led to a decline in patronage of these camps and only two of them (Nahmakanta Lake Camps and the White House Camps) remain available for public accommodation. In western Maine, there were few accommodations anywhere near the trail south of Sterling's Pierce Pond Camps, Steele's Camps on East Carry Pond, and the Ledge House at the Dead River Post Office. In addition to clearing much of the original route, the Civilian Conservation Corps built the first campsites, based on the classic Adirondack shelter or lean-to. South to north, the Rangeley CCC camp built the Grafton Notch, Frye Brook, and Squirrel Rock Lean-tos in 1936; Elephant Mountain, Sabbath Day Pond, and Piazza Rock Lean-tos in 1935; Poplar Ridge in 1937; Spaulding Mountain in 1938; Sugarloaf in 1937; the two Horns Pond Lean-tos in 1936; the Cold Brook Lean-to (on the abandoned Dead River Route) in 1935; Jerome Brook in 1938; and Pierce Pond Lean-to in 1938. Louis Chorzempa of Dryden, Maine, continued the project east of the Kennebec after World War II. Chorzempa became MATC president in 1957 and civil engineer Carl Newhall eventually picked up leadership for shelter construction. During the relocation era of 1970–1990 and beyond, the club built 33 new lean-tos and campsites to replace those bypassed by the relocations or simply in need of replacement. Today, none of the original CCC shelters remain in use.

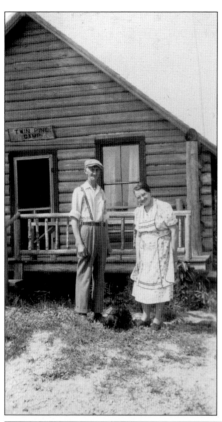

Earl and Maribel York pose at York's Twin Pine Camps on Daicey Pond in 1940. From August 18–26, 1939, York's Camps hosted the Ninth Meeting of the Appalachian Trail Conference. Following the conference, ATC and MATC members led a 120-mile trip from Katahdin to the railroad station in Blanchard, where many of the hikers boarded the Bangor & Aroostook Railroad to return home. (Photograph by Leland Goodrich.)

At the 1939 conference, the National Park Service's George L. Collins (acting assistant chief, Land Planning Division, with pipe) talks with Everett F. Greaton (executive secretary of the Maine Development Commission) and Myron Avery. They may well have been discussing Avery's proposal for a national park surrounding the Katahdin area.

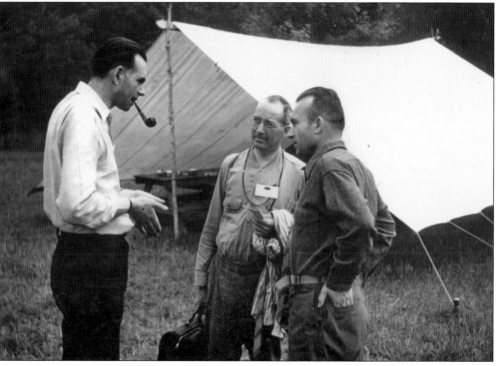

Pet deer were popular features of remote sporting camps along the trail, such as here at Clifford's Rainbow Lake Camps in the late 1930s. Avery described this location as "a wooded oasis in the burned lands on the south shore of the lake." The original AT required a canoe ferry across the lake to reach the camps, but the trail was later routed around the east end of the lake.

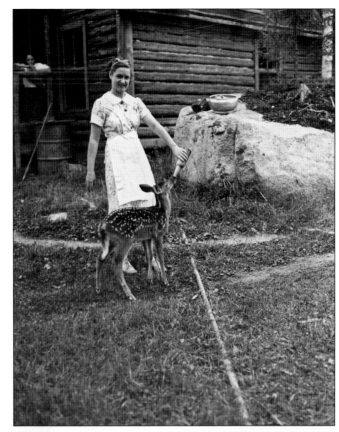

J. Frank Schairer found the deer willing to take a bottle from a guy also. Geochemist Dr. John Frank Schairer of the Carnegie Geophysical Laboratory in Washington, DC, was much honored for his professional work and was elected to the National Academy of Sciences in 1953.

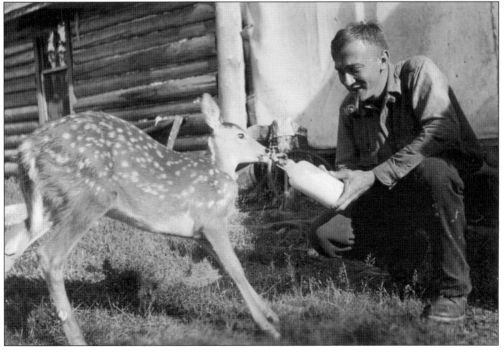

McDougal's Nahmakanta Lake Camps occupied a campsite of Penobscot Louis Ketchum, described in Fannie Hardy Eckstorm's book *The Penobscot Man*. The Nahmakanta Dam Company secured rights to build dams at the outlet of Nahmakanta Lake as early as 1837. Remains of the most recent dam remain visible.

Photographer F.J. Greenhalgh of New York City was generous in sharing photography with Myron Avery. Potter's Antlers Camps, seen here in 1932, was his favorite hunting and fishing retreat. In September 1933, he wrote, "Sorry to say I have returned from Heaven to Earth, which is the way I always feel returning to New York after a trip to the Maine woods." (Photograph by F.J. Greenhalgh.)

This red pine stand on the point at Leon Potter's Antlers Camps today shelters a Maine Appalachian Trail Club campsite. The Antlers Camps letterhead advertised "Deer, Moose, Bear, Duck and Partridge Shooting; Trout, Togue, Salmon, White Perch and Pickerel Fishing; Fishing, Hunting, Mountain Climbing, Bathing, Canoing." Guests could board a Pullman car in Boston, arrive at Norcross Station 12 hours later, and travel to Antlers by boat.

Leon Potter poles a canoe down Joe Mary Stream on his way back to Antlers in 1939. In July 1933, Potter wrote to Walter Greene about clearing a five-mile section of the route. He said that he could not do it himself, but "I think I can get a man to do it for $10 . . . I would need assurance that the man would be paid as this is a mighty hard year for us."

Berry's Yoke Pond Camps, no longer open to the public, lie in a beautiful setting north of the Boardman Mountains. In March 1933, Charles Berry wrote to Avery to suggest routing the Appalachian Trail from the East Branch of the Pleasant River, up past Mountain View Pond, then over a tote road to Yoke Ponds. Avery chose a different path, but in 1982, the MATC relocated the trail along much of Berry's recommended route.

Described by Avery as a generous, helpful man, Charles Berry, proprietor of Yoke Pond Camps, assisted Avery and Greene in 1933 with advice on routes and some clearing work between his camps and the West Branch Ponds. He kept several trails open in the valley of the East Branch of the Pleasant River for hunting and fishing use by his guests.

Chadwick's Camps on First West Branch Pond (above) were not directly on the trail route but were used by the trail explorers. Chadwick's outlying camp on Third West Branch Pond was close to the trail and could be reserved for use by hikers. Trail explorers also enjoyed this view (below) of the White Cap Mountain Range from the camps. The 130-year-old West Branch Pond Camps remain open to the public today under fourth generation family ownership.

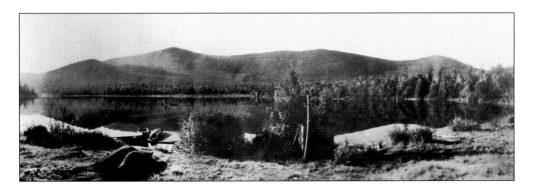

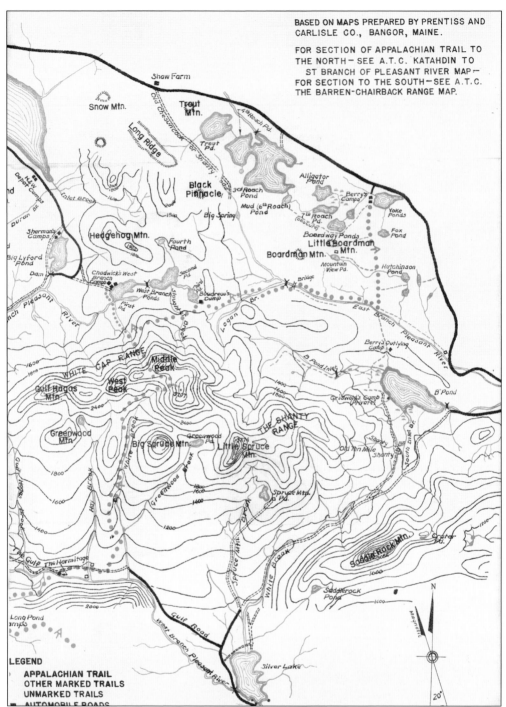

BASED ON MAPS PREPARED BY PRENTISS AND CARLISLE CO., BANGOR, MAINE.

FOR SECTION OF APPALACHIAN TRAIL TO THE NORTH— SEE A.T.C. KATAHDIN TO ST BRANCH OF PLEASANT RIVER MAP— FOR SECTION TO THE SOUTH—SEE A.T.C. THE BARREN-CHAIRBACK RANGE MAP.

Like much of the rest of the original Appalachian Trail through Maine, this 1935 route northwest of Katahdin Iron Works followed many miles of old logging roads. Almost none of the original path shown on this map remained in use after the 1970–1990 relocations. Two public sporting camps shown on the map (Chadwick's and Berry's), essential AT facilities when the trail was first opened, are no longer on the route. (ATC.)

York's Long Pond Camps (later Perham's) were located at the east end of Long Pond. Ralph York cut a side trail from the camps to the AT at Chairback Gap, from where another trail descended south to Arnold's Big Houston Pond Camps. These camps now belong to the Appalachian Mountain Club.

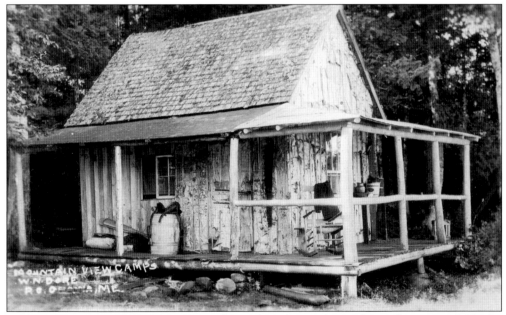

Will Dore's Mountain View Camps were located on the southwest shore of Long Pond. Shailer Philbrick recalled meeting Will on a tote road in 1931 as Dore was hauling supplies to his camp by horse and wagon. The horse died en route. "Thinking of the glacial soil full of rocks and difficult to dig, I asked if he had buried the horse. 'No,' he said, 'I just cut a new road around the horse.' "

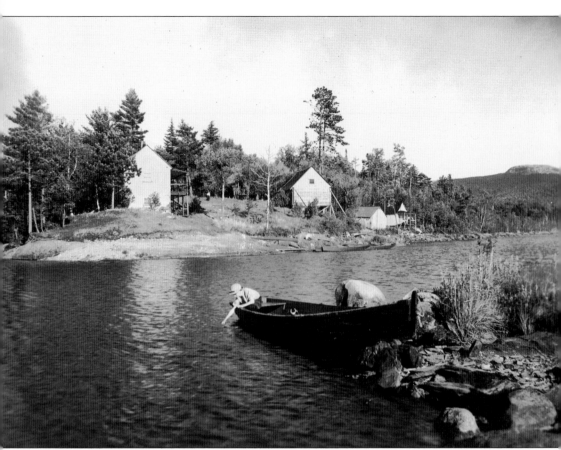

The original AT crossed Mosquito Narrows on Moxie Pond to reach Troutdale Camps. This 1909 photograph shows Moxie Bald Mountain in the right background. Hikers not lodging at the camps could arrange for a ferry ride for 25¢. J. M. Harris and his sons cut a connector section for the AT towards Moxie Bald Mountain (Photograph by Samuel Merrill.)

As the route for the Appalachian Trail was being explored, chief Maine fire warden Ralph Sterling, owner of a hotel in Caratunk, was building a set of sporting camps near Pierce Pond. A primary reason for the location of the Appalachian Trail through Caratunk was the Pierce Pond Tote Road Ferry, which Sterling established to carry guests and supplies across the Kennebec River. Shailer Philbrick noted that while his team was staying at the hotel during their 1933 expedition ("the beds are good, the grub is better—steak whenever you say so"), Sterling argued for routing the AT by Pierce Pond (not saying that he was behind plans to build a new set of camps there). Philbrick followed the guidebook route down the west bank of the Kennebec to Carrying Place Stream, but the final route went right by Sterling's camps. (Both, PPC.)

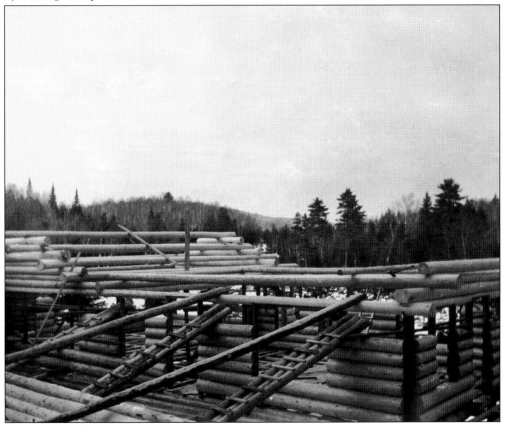

Sterling's Camps were classical Maine sporting camps, with a central log lodge and dining hall and individual log cabins for guests scattered around the property. In this photograph, Leona Sterling and a guest "from away" enjoy the comforts of the recreation room, complete with a pump organ. (PPC.)

Sterling's Camps' corduroy bridge carried the Appalachian Trail across Pierce Pond Stream, with the camps just 150 feet uphill from the west bank. The trail then turned up along the stream to Pierce Pond. Today, the original route serves as a side trail between Pierce Pond Lean-to and Harrison's Pierce Pond Camps. (PPC.)

Still in use today, the individual log cabins provided guests with privacy and solitude, while the central lodge offered opportunities for socializing, bragging about fish and game catches, and the all-important dining. The reputation of Maine sporting camps often depended (and still depends) heavily on the quality of the meals served. (PPC.)

Sporting camps along the Appalachian Trail attracted guests from all walks of life. Anna Roosevelt Boettiger, daughter of Franklin and Eleanor, enjoyed the fishing opportunities that attracted many to Pierce Pond Camps. (PPC.)

The covered porch at the main lodge still invites guests to sit and swap stories and enjoy the quiet of the forest. Although most AT hikers now spend the night at the nearby Pierce Pond Lean-to, the camps are known for welcoming hikers. Signs along the trail direct them to the lodge for drinking water, and the daily pancake breakfast offering is renowned from one end of the AT to the other. (PPC.)

The Potomac Appalachian Trail Club expedition of 1941 prepares to leave Steele's East Carry Pond Camps with Myron Avery (right). During the 1933 expedition, Shailer Philbrick reported, "Tell Frank that their grub was so far above any other place that it is worth his expenses to get up there someday and hit them at dinner time. Two kinds of pie for dinner and just a darn good place."

Although not a major facility right on the trail, AT hikers could arrange to stay at the Redington Pond Camps, remnant of the once thriving sawmill village of Redington on the Phillips & Rangeley Railroad. Proprietor Fred Hough and his wife, Nellie (third row, center), pose with guests, including Blanche Caswell (first row, left). A one-mile blue-blazed side trail from the AT to the camps was still visible in 1956. (PMHS.)

Although few of the original sporting camps remain open to AT hikers, hostels and boardinghouses in towns near the trail offer respite from campsite overnights. For many years, Shaw's Boarding House in Monson has welcomed and been welcomed by AT hikers. Pat and the late Keith Shaw created a legend for hospitality that continues under new ownership.

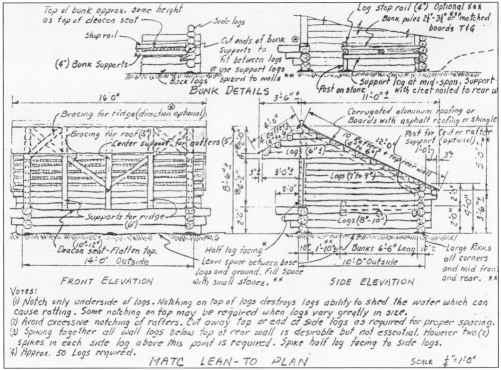

The CCC built Adirondack shelters at campsites along the trail in western Maine in the 1930s. These are elaborate versions of the simple forest shelter that has been used for millennia: tree boughs (or bark, or animal skins) leaned on a cross pole that is supported by two uprights to form an open-faced shelter. MATC Shelter chair Carl Newhall drew this design for the shelter in 1966.

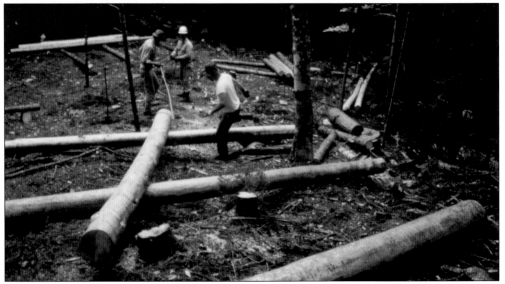

Except for roofing and bunks, Maine AT lean-tos are built from trees cut on site. Moving the logs may involve carrying, sluicing, a cable rig, or other ingenious methods of transportation. Here, a peeled log is sluiced over other peeled logs to the base of the Leeman Brook Lean-to in 1987. (Photograph by Lester Kenway.)

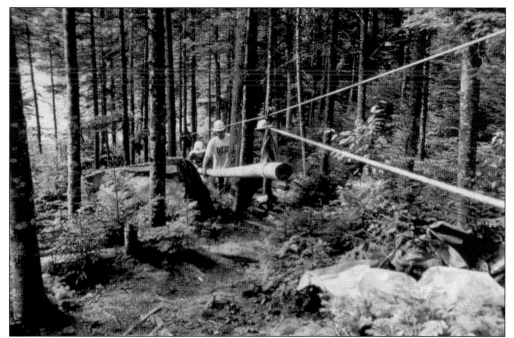

For many years after the AT was completed, hikers had to cross the Barren-Chairback Range or take a side trail to a sporting camp to find shelter. The MATC finally built a rough lean-to at Cloud Pond, but it was in bad shape by the 1980s. Here, a cable rig is used to move material for the new Cloud Pond Lean-to in 1992. (Courtesy of photographer Terry Karkos.)

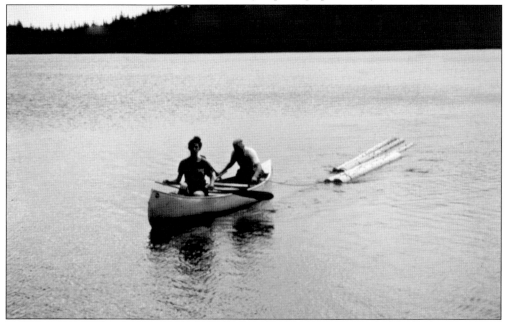

Sometimes, when there are not enough suitable trees near a shelter site, logs are prepared elsewhere and moved a bit farther than usual. Here, the "MATC Navy" hauls logs to the Sabbath Day Pond shelter in 1993. A similar operation took place during construction of the West Carry Pond Lean-to.

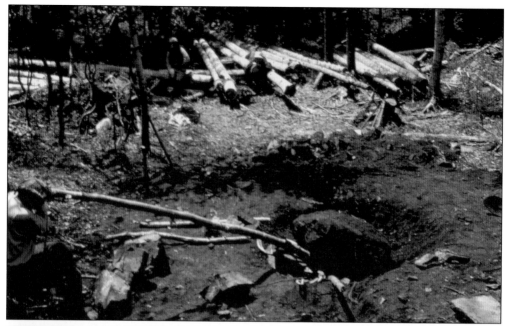

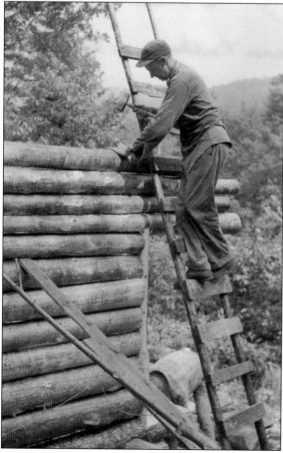

Appalachian Trail campsites are not always on level ground, and preparation for a new lean-to can be tiresome. Here, Carl Newhall, MATC Shelter chair, extracts a boulder from the site of the new Logan Brook Lean-to, completed in 1983 as part of the White Cap Relocation project. (Photograph by author.)

After the lean-to base is in place, the walls go up. James Faulkner works on the Long Pond Stream Lean-to in 1955, with overseer Sidney Tappan visible in front of the shelter. Tappan was overseer of the trail east of the Kennebec River for many years. (Photograph by Louis Chorzempa.)

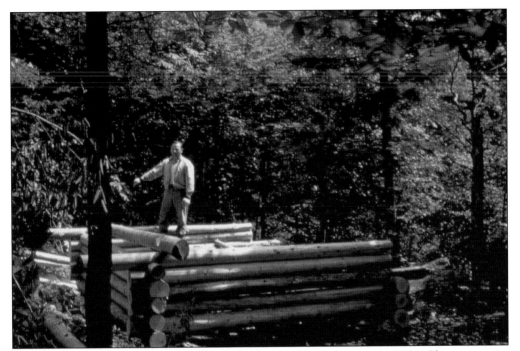

Shelter chair Louis Chorzempa works on the Cooper Brook Lean-to in 1956. Chorzempa was assistant overseer of trails under Myron Avery, overseer of the trail west of the Kennebec River from 1952 to 1957, and president of the MATC from 1957 to 1965. (Photograph by Steven Clark.)

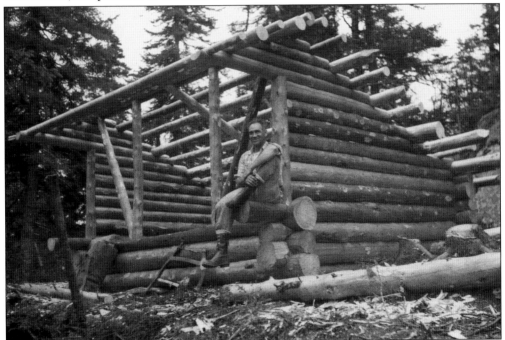

Clifton Bradley poses at the Chairback Gap Lean-to in 1954. No power tools were in use at that time (note the bucksaw) and the walls clearly show where the builders smoothed off knots in the logs with axes. (Photograph by Louis Chorzempa.)

From left to right, James Faulkner, Dr. James Miller, Dr. Roy Fairfield, Dr. Douglas Leach (three Bates College professors), and Clifton Bradley pose on the growing back wall of the Long Pond Stream Lean-to in 1955. (Photograph by Louis Chorzempa.)

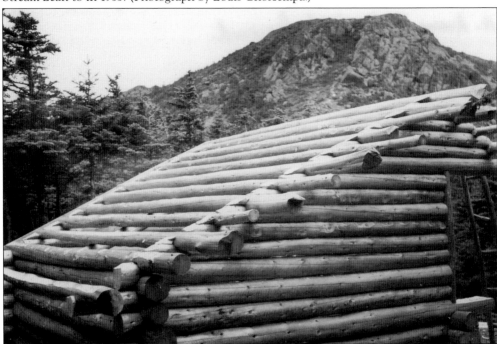

One of the first lean-tos added to the campsite chain after World War II was the Avery Memorial Lean-to in Bigelow Col, seen here on August 2, 1953, just before the roofing was installed. During the biennial meeting of the Appalachian Trail Conference in 1979, members of the PATC, honoring their first president, hiked up to the Col and replaced the infamous "baseball bat" bunk decking with boards. (Photograph by Louis Chorzempa.)

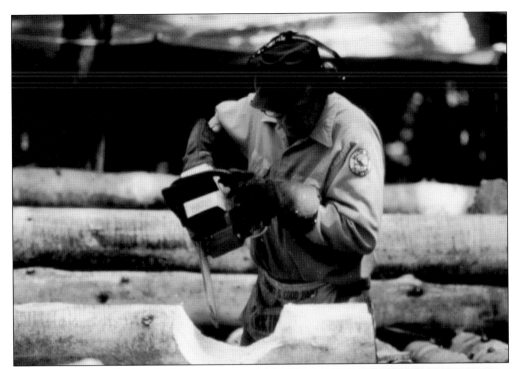

The relocation of the Appalachian Trail in Maine from 1970 to 1990 required the construction of many new lean-tos to replace ones that were bypassed by the relocations, as well as the replacement of several old CCC shelters that had worn out. Here, Frank Troutman, longtime MATC volunteer and both volunteer for and benefactor of Baxter State Park, shows his chainsaw artistry during construction of the Little Bigelow shelter in 1986. (Courtesy of photographer Christine Wolfe.)

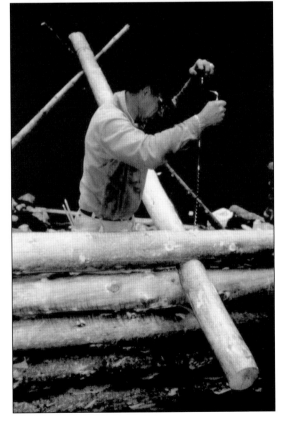

Sometimes, to avoid splitting logs, workers drill holes for the spikes. Here, John Morgan, president of the Maine Appalachian Trail Club from 1987 to 1993, uses a long auger to drill for the fastener between back logs and a wall rafter.

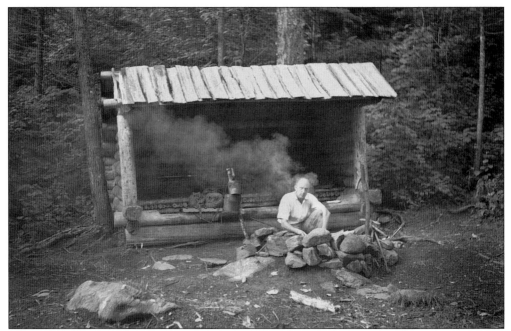

The Civilian Conservation Corps built 14 Adirondack-style lean-tos in western Maine during the 1930s. The roofing was usually hand-hewn fir shakes, which warped and began to leak not long after the shelters were built. Here, MATC director Lawson Reeves prepares supper at the CCC's Piazza Rock Lean-to in 1950. (MSL.)

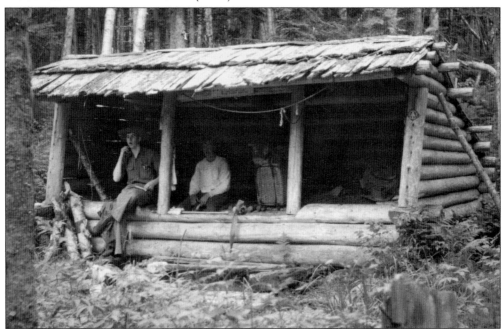

The author (left) and James Hanson relax at Spaulding Mountain Lean-to, which is showing serious signs of wear in 1956, twenty years after it was built. The hand-hewn fir shake roofing was in particularly bad shape, and the bunk poles had begun to cave in. The sill logs, resting on very wet ground with no rock support, were already rotting. (Courtesy of photographer Michael T. Field.)

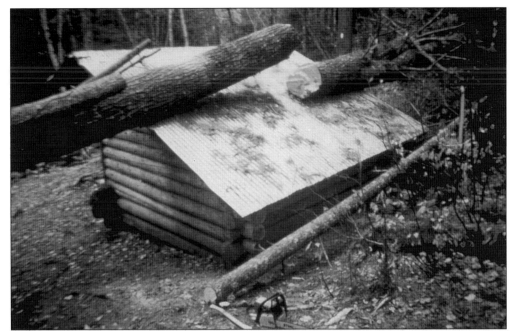

Maine lean-tos have to be tough, as shown by this pine tree "blowdown" (tree felled by wind) on the Rainbow Stream Lean-to in October 1996. Two hikers sleeping in the shelter when the tree came down were startled but not injured. Delicate work with chainsaws removed the hazard. (Courtesy of photographer Terry Karkos.)

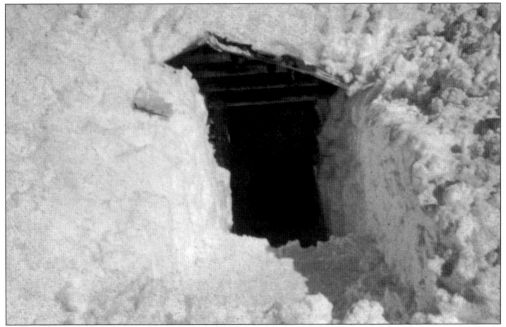

In addition to blowdowns, Maine lean-tos must deal with snow. The winter of 1957–1958 was a record breaker. At the Horns Pond campsite on Bigelow Mountain, both of the Appalachian Trail lean-tos were completely buried under the snow as shown here on March 28, 1958. Oddly, there was no snow on the ground in the area on New Year's Day. (Photograph by author.)

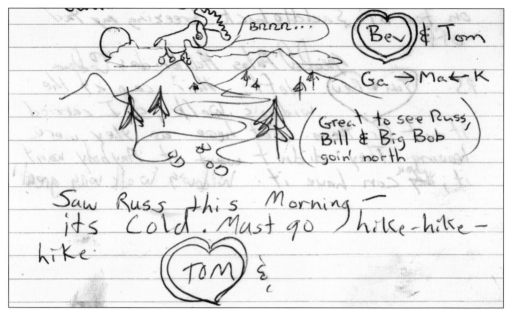

Lean-tos along Maine's Appalachian Trail not only provide shelter, but also socializing, especially among the "Through Hikers" who walk the entire AT each year. These "end-to-enders" often leave messages to each other in shelter registers, and impromptu artwork, such as this in the 1984 Poplar Ridge Lean-to Register, is common. (Courtesy of author.)

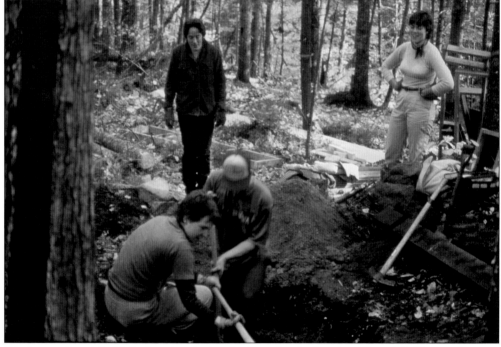

Digging a privy pit in Maine's rocky, glaciated soil can be challenging. These L.L. Bean volunteers at Cooper Brook Lean-to are doing well but have a long way to go before the hole is large enough. When a privy pit fills, volunteers dig a new one and move the privy building over it. The work is neither pleasant nor easy. (Courtesy of photographer Christine Wolfe.)

Five

MANAGING THE TRAIL

The Appalachian Trail through Maine was designed by volunteers, but the Civilian Conservation Corps, Maine Forest Service personnel, owners of sporting camps along the route, and local woodsmen hired for the task constructed the original trail. Following World War II, Myron Avery appealed to the Maine forest commissioner for help with re-clearing the neglected path. Trail maintenance became increasingly a volunteer effort, and the massive relocation of 164 miles of the trail in Maine from 1970 to 1990, along with the construction of new shelters and campsites, was planned, scouted, and built entirely by volunteers. Today, except for a few campsite caretakers and the MATC Trail Crew leaders hired to supervise volunteer workers on intensive footpath hardening projects, MATC volunteers maintain the trail in Maine north of Grafton Notch and monitor the National Park Service corridor lands along the trail. The club has divided the trail into 115 footpath management sections, 22 overnight site maintenance assignments, 70 corridor monitoring sections, and eight natural heritage monitoring sites that are assigned to individuals and groups. Some of the assignments have been in place for more than 50 years. Management involves getting to the trail (not always easy), clearing blowdowns and brush, maintaining paint blazes and signs, and caring for camping areas, shelters, and privies. In recent years, as trail use has increased, a great deal of time has been devoted to footpath hardening with bog bridges, rock steps, and log ladders to reduce the impact of hikers on the thin, fragile soil that is common in Maine's mountains. MATC volunteers must deal with many forces of nature, but one of the dominant enemies over the years has been the Maine black fly. In August 1947, trail overseer John W. Clark wrote to Myron Avery, "It is possible to paint with flies in one or even both ears; it is possible to paint with flies in both ears and one eye; but when they are in both ears and both eyes, the artistry of the brush wielding suffers."

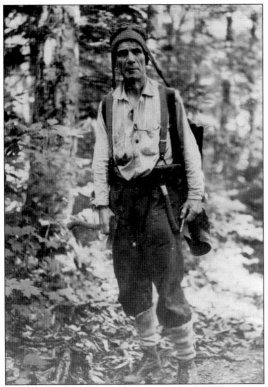

Shailer S. Philbrick caught this photograph of Walter Greene with his favored "tump-line" backpack in August 1932. Avery credited Greene, first president of the Maine Appalachian Trail Club, Maine guide, and Broadway actor, with having built the AT across the Barren-Chairback Range nearly single-handedly. He also scouted the route from Katahdin to Blanchard in 1932 and marked the trail from the Pleasant River to Blanchard in 1933.

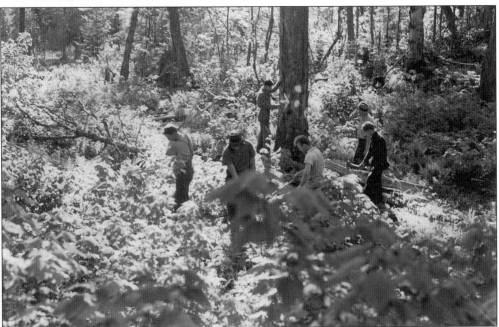

The Bates College Outing Club helped to survey and blaze much of the original Appalachian Trail from Grafton Notch to Saddleback Mountain and built a blue-blazed side trail up C Pond Bluff in 1935. Here, a Bates crew works on its section in 1938. The blazes are not "regulation," but the challenging work is obvious.

Prof. W.H. Sawyer (center) and Bates College Outing Club students break for chow during a 1938 work trip. Maine Forest Service rangers might have been a little nervous about that fire had they come across the group, but all apparently turned out well.

A strong Bates College Outing Club trail maintenance turnout (127 volunteers!) was recorded here on Saddleback Mountain, October 5, 1952. The spectacular open ledges of Saddleback's three-mile alpine zone provided an ideal setting for the photographer. For many years, the BOC maintained 34 miles of the AT from Saddleback south. Their remaining assignment on Bemis Ridge is the oldest continuous assignment within the MATC.

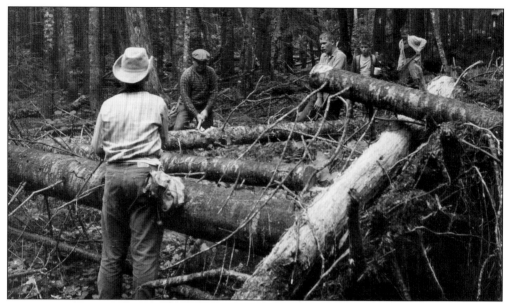

These Pine Island Camp boys removed 64 blowdowns along 1.3 miles of trail with their hand tools on this work trip in the 1950s. The Pine Island assignment, currently between Pierce Pond and the Kennebec River, is one of the oldest in the MATC. (MSL)

In October 1980, the University of Maine Forest Resources Club volunteered to begin clearing the White Cap Relocation. The club is, from left to right, (first row) M. Richards, D. Hatton, C. Girah, A. Goodwin, C. Gilley, B. Martin, S. Leinweber, M. Ladstatter, and C. McRae; (second row) B. McLaughlin, D. Newman, P. Orzech, J. Lentsch, D. Graves, D. Fosbroke, J. Stuart, J. Celia, S. Tonnessen, C. Billis, N. Mellen, J. Scnell, and D. Simonds; (third row) C. Nolstadt, S. Rich, T. Zilch, P. Miller, F. Allen, C. DuPerre, and E. Brown. (Courtesy UM School of Forest Resources.)

In August 1954, Hurricane Carol blew across western Maine and devastated the forests along the Appalachian Trail. In this 1956 photograph, James Hanson (left) and David Field work on a windrow of spruce-fir blowdowns along the high ridge between Spaulding and Sugarloaf Mountains. Lightweight chainsaws were not yet available, but a four-foot Sandvik pulpwood saw got the job done. (Courtesy of photographer Michael T. Field.)

The Sandvik pulpwood saws found use on the Bigelow range as well. Here, in 1956, David Field takes a break while Courtland Dill attacks a blowdown on the Bigelow Range Trail near Horns Pond. Hurricane damage was so bad that the Range Trail was not reopened for several years. (Courtesy of photographer Michael T. Field.)

In addition to axes and saws, standard tools for clearing the AT in Maine during the early years included the Lively Lad weeder, manufactured in Malvern, Arkansas, used here by Michael T. Field near Saddleback Jr. to prune back fir limbs. (Photograph by author.)

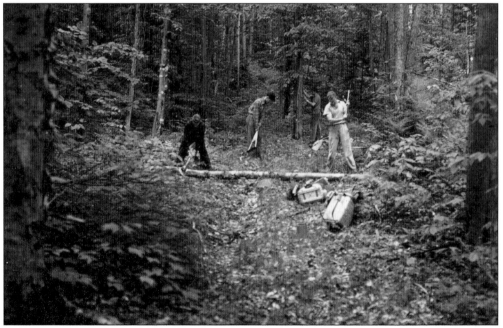

On a work trip in 1938, this Bates College Outing Club crew uses axes and a weeder to clear their section of the trail. Pack baskets, often bought from Maine's First Nation basket makers, were standard backpacks in those days, long before the development of lightweight frame packs and other alternatives to heavy canvas packs.

By 1975, packs had evolved far beyond the pack basket era, but the importance of the work done by volunteers is emphasized here by the difference between the path enjoyed by this hiker and the dense spruce-fir thickets along the sides of the trail. (Photograph by author.)

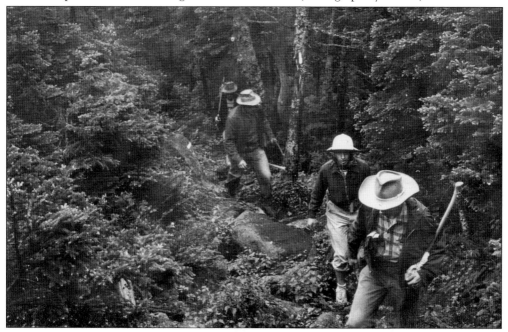

The trail in western Maine was still suffering from the ravages of 1954's Hurricane Carol when this crew of MATC volunteers (from left to right, Courtland Dill, Dennis Pillsbury, Norman Thurlow, and David Field) worked east of Avery Peak in 1957. Lightweight power tools were still not available. (Courtesy of photographer Michael T. Field.)

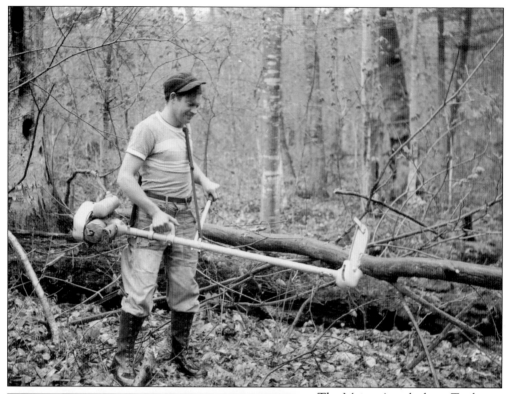

The Maine Appalachian Trail Club began to use power tools in the 1950s, but they were far from lightweight. Devices for small blowdowns and brush cutting, included this "Sawette," wielded by Charles Hardy on Sugarloaf Mountain in 1954 (above) and the "Scythette" used by Dick Summers (left) and Don Dinwoody of the Colby Woodsman's Club near East Carry Pond in 1955. (Both, MSL.)

Volunteers began to carry chainsaws into the mountains in the late 1950s, but the heavy weight of the early models discouraged widespread adoption. By the time the author was photographed crossing this ledge in Elliotsville in 1986, lightweight saws had greatly increased the productivity of trail workers, just in time for the relocation era. (Courtesy of photographer Lester Kenway.)

Certainly one of the more curious power tools used in recent years was this chainsaw-drive "hedge clipper," wielded by Richard Innes on Lone Mountain in 2001. Brush clearing remains one of the most time-consuming and tedious trail maintainer duties, and many different tools have been tried out over the years. (Courtesy of photographer Tony Barrett.)

Wind and snow are not the only forces of nature confronting volunteer trail maintainers. The spruce budworm epidemic of 1976–1983 killed thousands of balsam fir trees along the trail, leading to years of additional blowdowns as the dead trees broke off across the path. This June 1962 forest fire in Redington Township represents a hazard that is constantly present. (Photograph by author.)

The scar of the 1962 Redington fire is still visible on Redington Pond Mountain, at left in this 1990 photograph from Poplar Ridge, as are clear-cut patches from spruce budworm salvage logging at the right below Sugarloaf and Spaulding Mountains. In the distance, communication towers and other developments are visible on the summit of Sugarloaf, no longer on the route of the AT in Maine. (Photograph by author.)

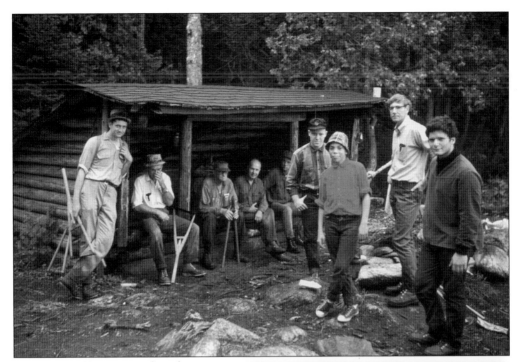

In August 1967, a crew gathered to clear the trail near East Carry Pond Lean-to. The photograph shows two traditional tools: the Lively Lad Weeder and Diston No. 4 long-handled clippers, both used from the 1930s to today. The second, third, and fourth persons from the left are Shelter chair Carl Newhall, MATC director and Baxter State Park supervisor Helon Taylor, and former MATC president James Faulkner. (Courtesy of photographer Richard Innes.)

Bates College Outing Club members Jill Farrar and Sybil Benton clip brush on the Barren-Chairback Range in September 1955. The BOC was helping the Woodsman Club get started on Colby's new trail assignment. The clippers were not the classic Diston models, but they got the job done.

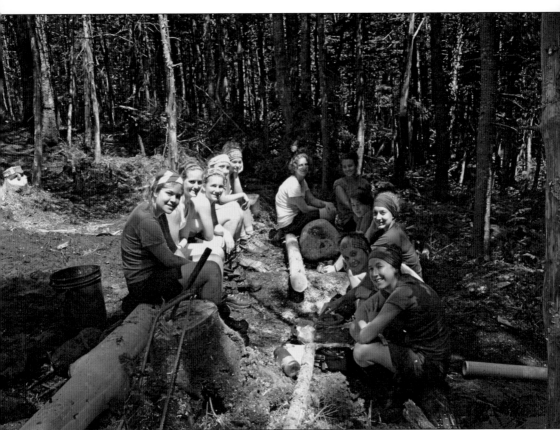

Young women from Camp Tekakwitha, a French language immersion summer camp in Leeds, Maine, take a break in 2008 while helping to build the new Redington Stream Campsite on the Saddleback Mountain Range. Camp Teki boys and girls, most from Quebec, volunteer many hours each year to help the Maine Appalachian Trail Club with a variety of trail construction and maintenance tasks. (Photograph by author.)

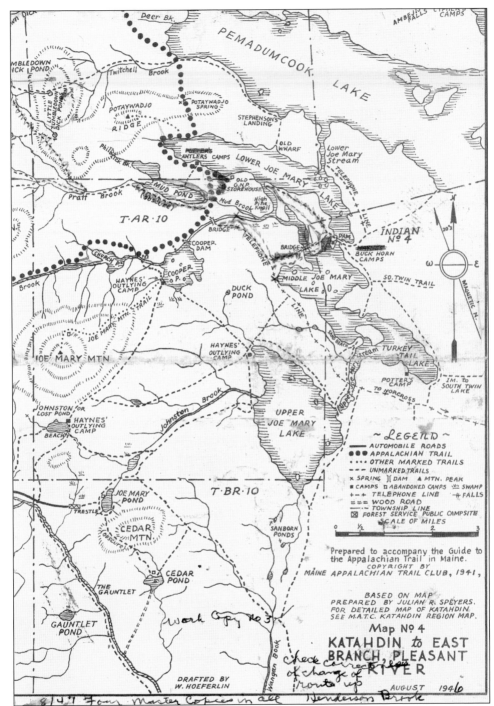

In addition to keeping the trail open, providing overnight facilities, and monitoring the corridor lands, Maine Appalachian Trail Club volunteers write and publish the *Guide to the Appalachian Trail in Maine*. Especially during the early years, and through the relocation era, keeping trail data and maps up-to-date has been a daunting task. This 1946 mark-up of the 1941 Map No. 4 illustrates that effort.

GUIDE TO
THE APPALACHIAN TRAIL
IN MAINE

PUBLICATION NO. 4
(FOURTH EDITION)
THE APPALACHIAN TRAIL CONFERENCE
(INCORPORATED)
WASHINGTON, D. C.
1942

Another challenge has been reducing the size of the guidebook. The 1942 fourth edition weighed 22 ounces and was 1.5 inches thick; the 2009 15th edition weighs nine ounces and, with the maps, is an inch thick. The 1942 text included the helpful but debatable note, "Black flies mosquitoes, and midges, which are somewhat prevalent in the Maine woods from May thru July, have generally disappeared by the middle of August."

Once the new guide and maps have been printed, MATC volunteers gather to assemble them into sales packages. Here, from left to right, Frank Troutman, Steven Clark, and Sally Field gather books and maps and stuff them into plastic bags prior to sending them to the Appalachian Trail Conference for merchandising. (Photograph by author.)

From the 1930s to the 1950s, signs along the Appalachian Trail in Maine, such as this one in Grafton Notch in 1937, used black stencil lettering on a white-painted board. Walter Greene worked during the winter of 1934–1935 to letter 125 board signs for the then completed 181 miles of the trail in Maine, with PATC member Dr. L.F. Schmeckebier contributing another 25. (Photograph by John Libbey.)

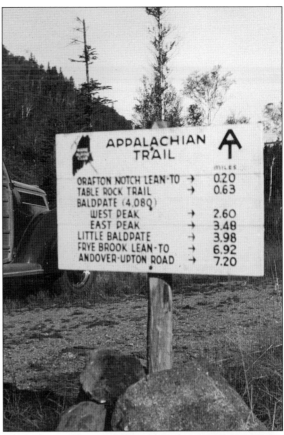

Today, MATC volunteers make and maintain some 400 routed wooden signs to guide hikers along the trail through Maine. Keeping these up-to-date during the relocation era required a major effort. This sign is at the junction of the Gulf Hagas Cutoff Trail and the AT. (Photograph by author.)

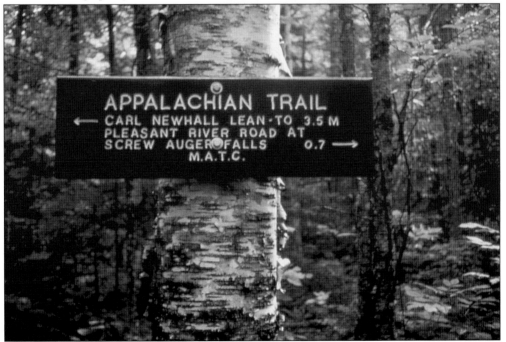

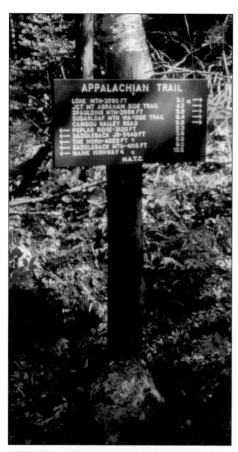

This sign, set near Sluice Brook in 1988, illustrates not only the workmanship that went into the routed lettering but also other chores that go with placing a major sign—cutting and peeling a sign post, digging a hole for the post, and fastening the sign to the post with lag screws after boring holes for the screws. (Photograph by author.)

The Katahdin summit sign suffers from severe weather and must be replaced every few years. This 1963 photograph shows MATC volunteer Steven Clark packing the new sign up the mountain. There is no easy way to do this.

This unusual AT sign was put up on Moxie Bald Mountain in 1963 at the site of the old fire warden's cabin. Thirty years earlier, Shailer Philbrick and Elwood Lord were marking the trail route up the mountain when they lost their way in darkness and thick growth. They followed a telephone line and eventually saw a distant light, which proved to be a lantern hanging beside watchman Taylor's privy. (Photograph by Stephen Clark.)

From Georgia to Maine, the Appalachian Trail is marked by two-inch-by-six-inch white rectangular paint blazes, which volunteers must regularly renew and replace as paint fades and trees blow down. Here, Floyd Flagg applies a new blaze in 1955. For years, trail managers felt that only a specially formulated oil-based paint was suitable to mark the route, but today water-based paints are commonly used.

A well-worn footpath requires less blazing, but autumn leaf-fall and snow cover the footpath, blazed trees fall down, and annual growth can obscure the route. The distinctive Appalachian Trail blaze is a welcome sight to an uncertain hiker. The metal AT diamond marker that was used to mark the original trail is no longer used. (Photograph by author.)

Six

REBUILDING THE TRAIL

Several major relocations of the trail in Maine had been completed between 1937 and 1968: from Nesowadnehunk Stream via Abol Bridge to Rainbow Ledges after the second collapse of the West Branch cable bridge in 1955; from Crawford Pond to the Little Boardman Side Trail after the closing of Yoke Ponds Camps to the public; off from the Barren-Chairback Range during World War II logging; around the south end of Moxie Pond after the closing of Troutdale Camps; across the Great Carrying Place along Arnold's Trail as an alternative to the "Dead River Route" (which was later abandoned in 1939 because of hiker preference for the new route and the flooding of the original by the creation of Flagstaff Lake); and along Bemis Ridge in 1957.

In 1968, with passage of the National Trails System Act, the MATC reviewed the location of the AT in Maine to see if it could be improved before it became permanently protected through landowner agreements or public acquisition. More than half of the original trail had been located on old logging roads and public roads. The original trailblazers lacked the time and the labor resources to consider better alternatives. The 1968 review, and subsequent planning, led to a new trail construction program that saw 173 new miles of trail built by the MATC over the next 20 years, as well as the replacement of many shelters. (Final relocations totaled 164 miles, but another nine miles of new trail were abandoned in favor of newer relocation choices.) The relocations were designed to place the trail permanently on routes that were better suited to the multiple goals of a rewarding user experience, harmonious relations with landowners, and effective management. The relocation program continued through the 1970s and 1980s, as the club worked with landowners, ATC, and state and federal agencies to secure a permanent, protected location for the Appalachian Trail in Maine. Although some relocation work continued through 2010, the last major relocation was completed in the fall of 1989. All of the 173 miles of new trail cut by MATC volunteers from 1970 to 1990 had to be cleared through unbroken forest.

To show a good example of the 1970–1990 relocation work, the author has plotted the Little Swift River Pond Relocation (dashed line) on a 1941 plot of the AT route (dotted line) drafted by W. Hoeferlin for the 1942 *Guide to the Appalachian Trail in Maine*. Almost the entire original route shown here was on roadways. None of the 15-mile relocation, opened from 1973 to 1975, was located on roads.

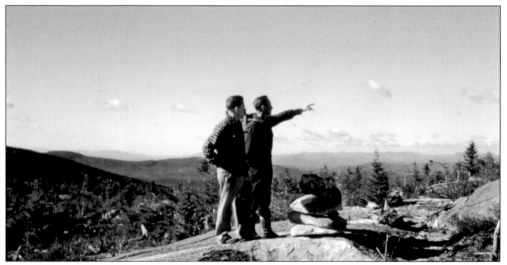

From left to right, MATC president Roy Fairfield and overseer of the trail for western Maine Louis Chorzempa scout for the Bemis Mountain Relocation in 1955. Plastic surveyor's flagging was not available in those days. The relocation was marked with twine strung through the trees where possible, but much of the route was over open ledge.

Exploring for the Bemis Mountain Relocation in 1955 are, from left to right, Louis Chorzempa, Kirk Watson (Bates College, 1956), and Reid Pepin (Bates, 1955). The Bates College Outing Club cleared the relocation, which was opened in 1957. The BOC still maintains this section.

Simply reaching the trail to scout or work on a relocation was often challenging. Long Pond Stream in Bodfish Intervale often flows down the road in the spring, as Frank Trautman found when he tried to drive his van over the route. From left to right, Trautman hooks a chain to the rescue vehicle as Lester Kenway offers advice. (Photograph by Terry Karkos.)

Ned Claxton tries to convince Dave Field that Dave can drive his Land Rover over a patched-up bridge over Vaughan Stream in Bodfish Intervale during work on the Elliotsville Relocation in 1983. The advice was accepted without mishap. (Photograph by author.)

Washouts are a constant threat. Access to sections of the trail varies from year to year as old roads come and go. This logging road was once the roadbed of the narrow-gauge Phillips & Rangeley Railroad. During the past 50 years, conditions along the roadway have varied from excellent to impassable. (Photograph by author.)

Relocation volunteers sometimes used a floatplane service to reach a remote area. Here, Lester Kenway wades ashore to begin exploration with David Field and ATC Northeast Regional representative Roger Sternberg for the White Cap Relocation on July 28, 1979. Although not visible in the picture, several moose watched the proceedings. (Photograph by author.)

The Blanchard Relocation along the West Branch of the Piscatquis River was completed in 1987. Work crews faced the challenge of crossing the river. Here, in Horseshoe Canyon, a Maine Appalachian Trail Club volunteer enjoys the thrill of a cable ride to cross the stream dry footed. (Courtesy of photographer Terry Karkos.)

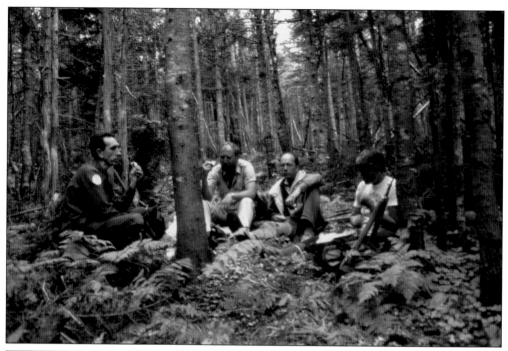

During work on the Lone Mountain Relocation in 1985, a writer and the photographer for National Geographic's 1988 book *Mountain Adventure: Exploring the Appalachian Trail* joined MATC volunteers for a day. From left to right, Richard Innes, senior writer Noel Grove, photographer Sam Abell, and Mac Smith enjoy a snack before continuing work. (Photograph by author.)

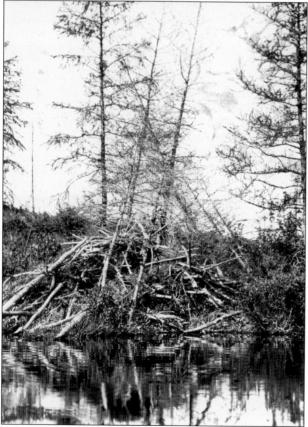

Maine wildlife, from the ever-present moose to mooching Canada Jays, were common sights to the explorers who laid out the new trail during the relocation era. But the modern explorers also faced a challenge that confronted the 1930s trailblazers. This beaver lodge on Church Pond represents the energy of these large, amphibious rodents who have caused innumerable relocations of the Appalachian Trail around their flowages. (Photograph by author.)

Maine's glaciated mountain terrain
has little soil. Abundant rainfall keeps
low spots chronically wet. MATC
trail managers use log bog bridges
(puncheon) and rock steps in the muddy
areas. Volunteers build bog bridges
by felling a spruce, fir, or cedar tree,
slicing it lengthwise with a chainsaw,
then spiking the half-round log to cross
pieces. (Photographs by author.)

Where large trees are not available to make bog bridges, rock slabs can sometimes be used. Mac Smith admires a "sidewalk" in Saddleback Mountain's alpine zone that he and the author have just installed across a bog hole in 1980. The rock in this area fragmented easily into relatively thin, but still heavy, slabs. (Photograph by author.)

Some of the original trail through Maine was laid out directly up steep slopes. Severe erosion, such as seen here on the old trail up Bigelow in 1975, has required relocation or step work. Rock step work is the most labor-intensive work done by the MATC. Maine trail crew workers are recruited primarily from outside the regular club membership and are led by paid supervisors. (Photograph by author.)

Log ladders and water bars reduce erosion on steep slopes. Robert Proudman, Appalachian Trail Conference Trail Management coordinator, looks over Sawyer Notch from the side of Hall Mountain in 1986. The original AT followed a logging road through the valley, but relocating the route to high ground required the trail to cross the steep-sided glacial cut between Hall Mountain and Moody Mountain. (Photograph by author.)

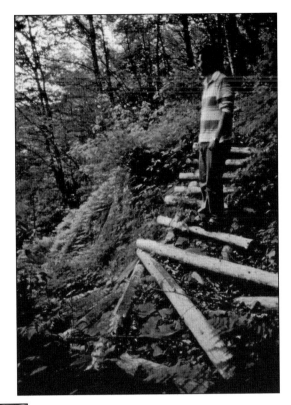

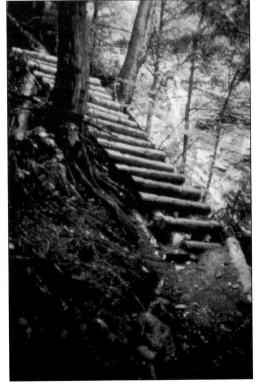

These steep log steps provided a spectacular view of Sluice Brook Falls (visible in the background) in Orbeton Canyon, but they eventually proved to be too slippery to be safe and were replaced after 11 years by a rock stairway in 1996. The new stairway begins with two steps carved out of bedrock by a gasoline-powered rock drill. (Photograph by author.)

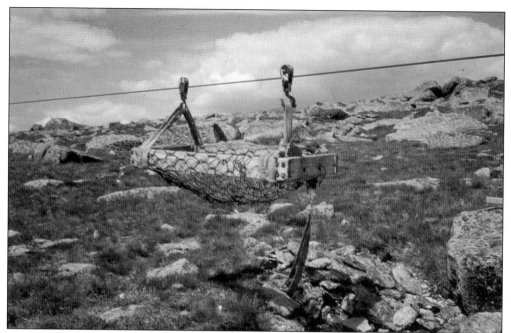

The ultimate "trail hardening" technique on steep slopes is rock step and rock water bar work. The Maine Appalachian Trail Club trail crew has built 757 rock steps on the north slope of White Cap Mountain during the past decade. Here, on Katahdin's Hunt Trail, a "rock tram" carries material for steps and scree walls. (Courtesy of photographer Lester Kenway.)

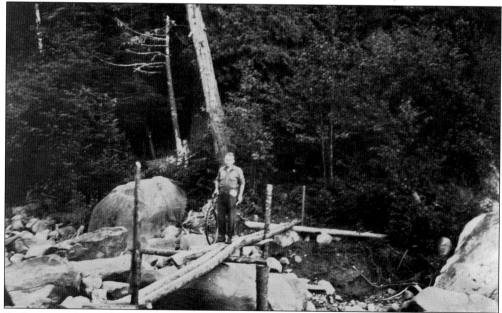

Broken ice cakes and tree debris sweep with great force down Maine rivers and streams during the spring. The Maine Appalachian Trail Club provides few bridges along the trail in Maine, both to retain the wild nature of the trail experience and because of the practical difficulty of dealing with spring floods. In this 1930s photograph, Myron Avery measures a somewhat shaky construct over Long Pond Stream.

The Bates College Outing Club built this 55-foot bridge across Bemis Stream in 1974. It was still there when Charley Scott of Sherbrook Quebec, shown here, crossed in July 1975, but it washed out in floodwaters the next year. The club has not replaced it. (Photograph by author.)

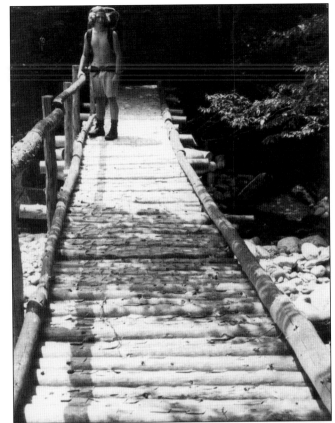

MATC volunteers have long taken advantage of natural water-crossing opportunities. In this 1930s photograph of Ted Whitten's Bridge, Myron Avery (left) and J. Frank Schairer test out a fallen birch tree across Little Wilson stream.

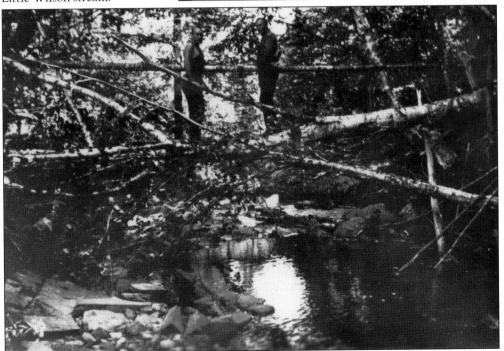

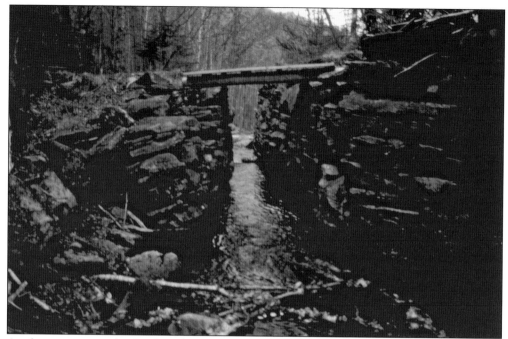

A relocation across the Sandy River in 1987 took advantage of magnificent old roadway stone abutments to anchor a short bridge that has withstood several floods. The trail follows the 1930s roadway for about 100 yards from the Highway 4 trailhead. (Photograph by author.)

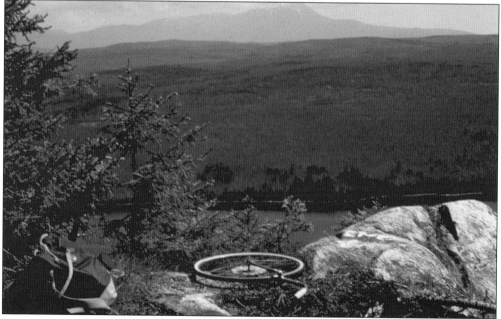

Just as Myron Avery measured each section of the original trail as it was completed, MATC volunteers "wheeled" the 173 miles of relocations from 1970 to 1990. Carl Newhall made this measuring wheel from bicycle parts. The author paused here on the summit of Nesuntabunt Mountain, looking towards Katahdin, as he measured the seven-mile Nesuntabunt Relocation in 1981. (Photograph by author.)

Seven

PROTECTING THE TRAIL

The 1968 National Trails System Act (Public Law 90-543) called for the secretary of the interior to establish the Appalachian National Scenic Trail. The law further specified that where the trail lies outside the boundaries of federally administered areas it be protected through cooperative agreements or land acquisition by the states or local governments or, failing action by those entities, by the secretary. Through the 1970s, the MATC, supported by the state, in particular forest commissioner Austin Wilkins, sought to obtain cooperative agreements with private landowners that would meet the expectations of the 1968 act. In November 1979, MATC president David Field submitted a "Draft Easement for the Appalachian Trail in Maine" that reflected agreements being considered by major landowners even as relocations were being explored. As of March 11, 1980, approximately 208 miles of the AT in Maine were located on private lands, with about 67 miles on public lands (including six miles of public roads). In 1980, International Paper Company donated some 1,200 acres of land in Elliotsville Township, including about seven miles of the trail, to the State of Maine. From 1986 to 1990, Great Northern Paper Company donated to the State of Maine conservation easement rights along its 26 miles of the AT that greatly restricted timber harvesting and road crossings and that gave the state the right to manage recreational uses of the property.

By the fall of 1983, it seemed unlikely that further contributions of land for a protective trail corridor would satisfy the requirements of the 1968 law. During a field trip on October 7, 1983, representatives of the NPS, the ATC, the MATC, and major landowners hiked in to Logan Brook Lean-to on the north side of White Cap Mountain. That evening, in Greenville, the decision was made that the National Park Service would take over the land acquisition program in Maine. The first NPS acquisition was made in August 1984. Today, all of Maine's Appalachian Trail extends across lands of the National Park Service, three state agencies (Bureau of Parks & Lands, Department of Inland Fisheries & Wildlife, and Baxter State Park Authority), and the Nature Conservancy.

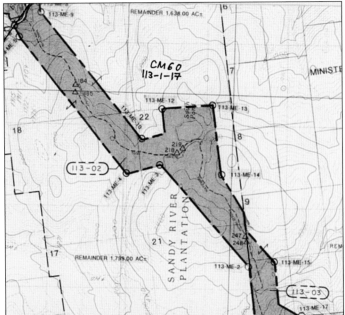

The MATC Executive Committee made recommendations for corridor design on December 2, 1983. In January 1984, David Field designed the original corridor based on a minimum width of 1,000 feet. That design was revised through discussions with ATC representatives and NPS officials. This segment, around Maine Route 4 near Rangeley, encloses all of South Pond, a design policy followed elsewhere in recognition of the likely future pressure on waterfront lands. (Courtesy of author.)

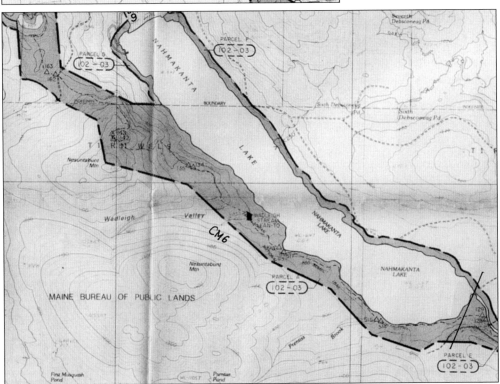

At a very long evening meeting in a Chinese restaurant in Augusta, Maine, in 1984, NPS AT regional coordinator for the North, Steven Golden; NPS realty specialist Gerald L. Kirwan; and David Field refined the entire Maine corridor design. That night, the decision was made to recommend including the entire shoreline of Nahmakanta Lake except for a parcel at the north end (which has since been acquired by the NPS).

NPS AT Project Office staffer David Sherman made the final adjustment to Maine's initial NPS corridor design in April 1985. He anticipated demands for radio and other transmission towers and added "spikes" out along ridgelines that he thought might be threatened by those demands to prevent such development. (Courtesy of author.)

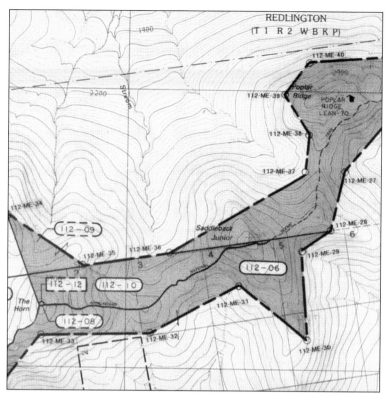

The 2,042 survey monuments that are inspected regularly by Maine Appalachian Trail Club Corridor Monitors mark the National Park Service corridor boundaries. Monitors also inspect the 301 miles of blazed and painted boundary line along the corridor (more than Yellowstone National Park), along with the "witness trees" surrounding each monument. (Courtesy of photographer Michelle Curtain.)

During a 1988 hike to consider corridor protection options, from left to right, David Sherman, Appalachian Trail Conference New England field representative Kevin Peterson, and National Park Service Appalachian Trail Project Office director Charles R. Rinaldi take a break at Nahmakanta Lake Camps. (Photograph by author.)

From left to right, Appalachian Trail Conference New England regional representative J.T. Horn, Appalachian National Scenic Trail park manager Pamela Underhill, and National Trails Land Resources Program Center realty officer Donald T. King pose at Surplus Pond in 2004, seventy years after Professor Sawyer and his Bates College Outing Club trailblazing team posed in almost the same spot. (Photograph by author.)

The MATC's latest class of volunteers, the Corridor Monitors, inspects Maine's 70 corridor-monitoring sections. Their patch duplicates the US Boundary signs that, in addition to painted blazes and survey monuments, mark the corridor boundaries. Monitors now inspect the 31,646 acres of NPS Maine AT lands as well as the state lands through which the trail passes. (Courtesy of author.)

WELCOME TO
APPALACHIAN TRAIL LANDS

PLEASE HELP US KEEP THESE LANDS IN THEIR NATURAL STATE FOR ALL TO ENJOY

TRAVEL ONLY ON FOOT

CARRY OUT ALL LITTER

MANAGED BY VOLUNTEERS
OF THE

Maine Appalachian Trail Club
P.O. Box 283
Augusta, Maine 04330

FOR MORE INFORMATION
CONTACT THE ABOVE TRAIL CLUB OR
THE APPALACHIAN TRAIL CONFERENCE,
P.O. BOX 807,
HARPERS FERRY, WV 25425
(304) 535-6331

PROHIBITED USES:

• TREE CUTTING

• ALL MOTORIZED VEHICLES

• HORSES AND PACK STOCK

• **CAMPFIRES**

(EXCEPT IN DESIGNATED AREAS)

U.S. GOVERNMENT PROPERTY
ADMINISTERED BY THE U.S.
DEPARTMENT OF THE INTERIOR,
NATIONAL PARK SERVICE

The sign that welcomes travelers to the National Park lands along Maine's Appalachian Trail also underscores the management obligations that have been added to the Maine Appalachian's Trail Club's traditional duties of trail footpath and campsite building and maintenance. (Courtesy of author.)

75th

1935-2010

Caretakers of the
Appalachian Trail in Maine

On June 19, 2010, the Maine Appalachian Trail Club celebrated the 75th anniversary of its founding and looked forward to the next 75 years of caring for the state, national, and international treasures to be found along Maine's Appalachian Trail. (Courtesy of Tony Barrett.)

BIBLIOGRAPHY

Avery, Myron H. "The Appalachian Trail." *Mountain Magazine*. VIII (2), 1930.

———. Draft description of the route of the Appalachian Trail in Maine for the New England Trail Conference's *Guide to the Appalachian Trail in New England*. MATC Archives, 1933.

———. Marking the Appalachian Trail in Maine. *In the Maine Woods*. Bangor & Aroostook Railroad, Bangor, Maine, 1934.

———. Developments along the Appalachian Trail in Maine during 1935. *In the Maine Woods*. Bangor & Aroostook Railroad, Bangor, Maine, 1936.

———. White blazes across Maine. *In the Maine Woods*. Bangor & Aroostook Railroad, Bangor, Maine, 1938.

———. Maine's Second Mountain. *Appalachia* Vol. 25, No. 3. June 1945.

Maine Appalachian Trail Club. *Guide to the Appalachian Trail in Maine*. Publication No. 4 (Fourth ed.) Washington, DC: Appalachian Trail Conference, 1942.

Philbrick, Shailer S. *Fifty Years after the Marking of the Appalachian Trail*. Unpublished manuscript. 1983.

Torrey, Raymond H. "The Appalachian Trail: From Maine to Georgia by Foot Trail—A Little Hike of 2,000 Miles—Along the Skyline of the Appalachian Ranges." *American Forests and Forest Life*, April 1924.

Wilkins, Austin H. *Ten Million Acres of Timber*. Woolwich, ME: TBW Books, 1978.

www.arcadiapublishing.com

Discover books about the town where you grew up, the cities where your friends and families live, the town where your parents met, or even that retirement spot you've been dreaming about. Our Web site provides history lovers with exclusive deals, advanced notification about new titles, e-mail alerts of author events, and much more.

MADE IN THE USA

Arcadia Publishing, the leading local history publisher in the United States, is committed to making history accessible and meaningful through publishing books that celebrate and preserve the heritage of America's people and places. Consistent with our mission to preserve history on a local level, this book was printed in South Carolina on American-made paper and manufactured entirely in the United States.

This book carries the accredited Forest Stewardship Council (FSC) label and is printed on 100 percent FSC-certified paper. Products carrying the FSC label are independently certified to assure consumers that they come from forests that are managed to meet the social, economic, and ecological needs of present and future generations.

FSC

Mixed Sources
Product group from well-managed forests and other controlled sources

Cert no. SW-COC-001530
www.fsc.org
© 1996 Forest Stewardship Council

Find Your Place in History.